THE FUTURE OF TENNIS

A Photographic Celebration of the Men's Tour

Philip Slayton and Peter Figura

Photographs by Peter Figura

Skyhorse Publishing

Skyhorse Publishing books may be purchased in bulk at special discounts for sales promotion, corporate gifts, fund-raising, or educational purposes. Special editions can also be created to specifications. For details, contact the Special Sales Department, Skyhorse Publishing, 307 West 36th Street, 11th Floor, New York, NY 10018 or info@skyhorsepublishing.com.

Skyhorse® and Skyhorse Publishing® are registered trademarks of Skyhorse Publishing, Inc.®, a Delaware corporation.

Visit our website at www.skyhorsepublishing.com.

10 9 8 7 6 5 4 3 2 1

Library of Congress Cataloging-in-Publication Data is available on file.

Cover design by Tom Lau
Front and back cover photo credit Peter Figura

ISBN: 978-1-5107-2745-8
Ebook ISBN 978-1-5107-2746-5

Printed in China

TABLE OF CONTENTS

THE FUTURE OF TENNIS

"Just you and me, baby."—Pancho Segura

Everybody who goes to Africa knows about the Big Five game animals—the lion, leopard, rhinoceros, elephant, and Cape buffalo. Everybody who has an interest in men's professional tennis knows about the Big Four—Federer, Nadal, Djokovic, and Murray (some add Wawrinka to this group, conveniently making it the Big Five as well). The Big Five have ruled the African veldt forever. The Big Four (or Five) have dominated men's professional tennis for years. But all the time there have been other players, some with great talent and personality. Who are these athletes, playing in the shadows? Which ones challenge the Big Four today? Who among them will, tomorrow, replace the champions who reign today?

In 2016, change seemed to be in the air. Roger Federer, perhaps the greatest tennis player ever, was turning thirty-five that year—hardly old in the grand scheme of things, but certainly considered "up there" in the world of professional tennis. Furthermore, Federer hadn't won a Grand Slam since Wimbledon in 2012. Federer's great rival, Rafael Nadal, was heading in the same direction: he was born in 1986 and had last won a Grand Slam at Roland Garros in 2014 (and Roland Garros was a special case; after all, the French Open virtually belonged to Nadal). Novak Djokovic and Andy Murray? Also getting old for tennis players, and they were late bloomers, racked by injuries, and had become erratic performers. The days of the Big Four, trading the world No.1 ranking back and forth, slapping each other on the back in the locker room, were surely almost over.

In 2017, the seemingly inevitable unfolding of events was delayed. Roger Federer won the Australian Open and Wimbledon (and then went on to win the Australian Open in January 2018—as journalist Kevin Mitchell put it in the *Guardian*, "rejuvenated yet again in the twilight of his career"). Nadal won Roland Garros and the US

1

Open. As 2017 drew to a close, Nadal was ranked No. 1 and Federer was ranked No. 2. At the end of 2017, journalist Zac Elkin commented, "Another season of tennis has come and gone and so has another unanswered call for the younger generation to snatch the sport from the grasp of the old masters." But the tennis world wasn't completely static in 2017: by the end of the year, Djokovic had sunk to No. 12, and Andy Murray was at No. 16, his lowest ranking since 2008. Both players, hobbled by injuries, missed tournament after tournament, or were defeated early on, or retired from matches. The Association of Tennis Professionals (ATP) finalists in November 2017 were not Federer and Nadal, nor Murray and Djokovic, but Gregor Dimitrov and David Goffin, both virtually unknown a short time before (Dimitrov won). Mitchell wrote in the *Guardian* in early 2018, "The old order looks very much in a state of meltdown." The challengers were moving to the fore.

Who among the challengers would eventually replace the old order, when the time inevitably came? Would the new giants of the game come from the stalwarts, those who had been beating loudly and insistently at the Big Four door for some time—players like Stan Wawrinka, Juan Martín del Potro, Gaël Monfils, Kei Nishikori, Milos Raonic, Grigor Dimitrov, Jack Sock, and Marin Čilić? Or would they come from the brash, those preternaturally gifted at the game, picked for greatness by some, but burdened by a bad temperament—the likes of Fabio Fognini, Ernests Gulbis, Nick Kyrgios, and Bernard Tomic? Or from the kids, who had seemingly come out of nowhere and likely had a long career ahead of them—David Goffin, Dominic Thiem, Sascha Zverev, and Denis Shapovalov? And how

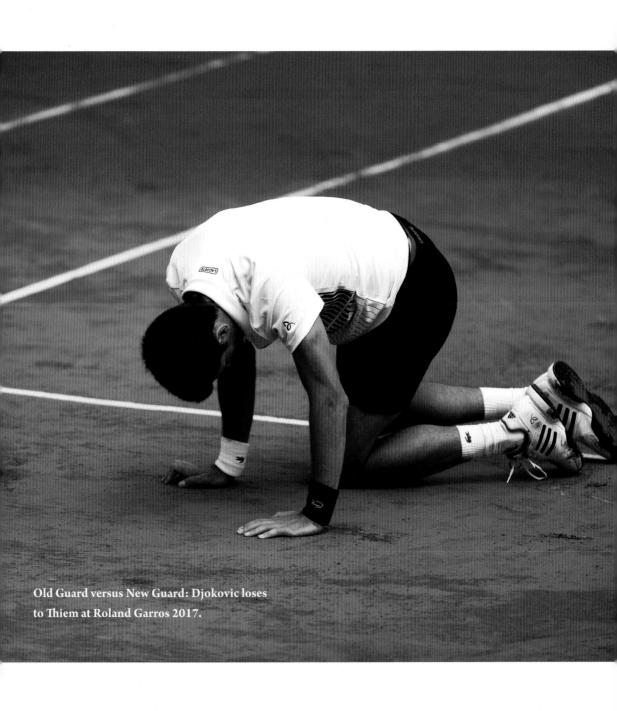

Old Guard versus New Guard: Djokovic loses to Thiem at Roland Garros 2017.

to measure and understand these contenders? Could it be done by comparing them to the senior statesmen of the game, whose long careers have come to an end, players like Tommy Haas and Daniel Nestor?

Men's professional tennis is a lonely game and a hard game. A player who aims for the top faces great obstacles and he faces them by himself—physical and psychological demands, endless travel, financial pressure, intense scrutiny from fans and critics, and an irrational system. The great champion Pancho Segura, who came from an impoverished Ecuadorian background, once described tennis this way: "It's a great test of democracy in action. Just you and me, baby. Doesn't matter how much you have, or who your dad is, or if you went to Harvard or Yale or whatever. Just you and me."

In many cases, tennis contenders are young people with little life experience and poor education. Almost all their time from an early age has been spent practicing and playing tennis and traveling the world. The brutal ATP schedule, with its mandatory playing requirements (for example, in most circumstances Top 30 players must in a year play all nine Masters 1000 singles events and at least four Masters 500 tournaments), offers little time for rest and requires incessant travel. The season starts at the beginning of January and ends with the Davis Cup finals at the end of the year. Elite players, those at the very top of the rankings, have entourages (coaches, hitting partners, dietitians, fitness trainers, physiotherapists, business managers, agents), the use of private jets, and luxurious accommodation, to help them along the way and lessen the pain. They have huge incomes. At the end of 2017, Rafael Nadal's earnings over his sixteen-year career were $91 million (this is prize money only, and does not include endorsements, which have been estimated to be worth as much as $50 million a year). But the rest, those who aspire to greatness but will likely end up as also-rans, travel economy class, generally by themselves or perhaps with a single coach, stay in motels, and typically have incomes of less than $100,000 a year.

And then there's ranking. The complicated and strict Emirates ATP rankings system is described by the ATP as a "historical objective merit-based method used for determining entry and seeding in all tournaments." It is extraordinarily demanding, oppressive even. The system has players constantly seeking new points to increase their playing opportunities and trying to protect points they already have by doing at least as well in any week as they did in the same week the year before. Filip Bondy wrote

in *Forbes* magazine at the end of 2017 that men and women tennis players should be playing less often, which will help their long-term fitness: "The best players are more vulnerable to fatigue problems because they go deeper into knockout tournaments and therefore must play more matches. . . . Tennis needs to change the way it ranks players, diminishing the need to participate in so many tournaments." Sponsorship contracts compound the pressure created by the ATP ranking system by offering big bonuses for improved ranking and performance.

Other absurd rules create perverse monetary incentives. In many tournaments, including the Grand Slams, prize money is awarded to a player who walks off from a first-round match (known as a "retirement") because of injury or any other reason, even if it's after just a few minutes of play. At Wimbledon 2017, there were seven retirements in the first round of men's singles tennis. (First-round Wimbledon losers have received about $45,000 just for taking the court and beginning the match.) The injured and the uninterested have shown up, not to play, but to collect a check for doing nothing. In November 2017, in an attempt to improve this situation, the Grand Slam Board announced that, beginning with the 2018 Australian Open, fifty percent of first-round prize money would be awarded to injured singles players who withdraw on-site before midday on the Thursday before the start of the main draw.

The brutal schedule and constant pressure to compete produce injuries galore. By November 2017, Djokovic, Murray, Wawrinka. Berdych, Kyrgios, Nishikori, and Raonic, all Top-20 players, had ended their 2017 seasons prematurely because of injuries. Djokovic, Murray, and Wawrinka didn't play after Wimbledon. None of 2016's final top 5 played in the 2017 United States Open. And elite players—the prime example is Roger Federer—are increasingly willing to take time out of the schedule to rest and recuperate.

Changes are coming. The Big Four will fade into history. More attention will be paid to those who have been playing alongside them, some of them startling characters, all of them gifted in various ways. A new dominant generation will arise, drawn from these other players. The Association of Tennis Professionals will have to reform the rules for international play. Tennis will remain a rough life, particularly for those who are not quite at the top. But the essence of tennis—a mysterious, beautiful, and lonely game—will remain the same.

STALWARTS

Stan Wawrinka

"Try Again. Fail again. Fail better."—Stan's tattoo

Stan Wawrinka—goofy guy, terrible dresser, late bloomer, and in the shadow of Roger Federer for many years, is now out of Federer's shadow (maybe), and a tennis giant himself (although, in his usual self-deprecating way, he denies greatness).

Wawrinka grew up on a farm, but not an ordinary farm. The eighty-acre Centre Social et Curatif in St.-Barthélemy, Switzerland, owned by a charitable foundation run for decades by his mother and father, shelters about fifty adults with mental disabilities. Wawrinka told a Swiss newspaper, "I had a very happy childhood. I was lucky to grow up surrounded by nature and animals, to be outside all the time and to work on a big farm with my dad. By growing up at a center for people with special needs, I learned to always fight hard to achieve what I want."

Federer, Nadal, and Djokovic were winning big titles in their late teens and early twenties. Wawrinka, roughly their contemporary, looked up at them from far down in the rankings, only reaching the Top 10 in 2013 when he was twenty-eight (he was born in March 1985). Even then, although 2013 was generally a good year for him, things could be tough. At the 2013 Australian Open, Novak Djokovic beat him in a five-hour fourth-round match. The *New York Times* commented, "Despite his solid, powerful frame and abundance of shot-making talent, which includes one of the world's best single-handed backhands, Wawrinka, 27, has long played in the deep shadow of tennis greatness. He is the second best Swiss player in the age of Federer. . . . And even on Sunday night, in the match of Wawrinka's life, Federer still intruded in a fashion as watch commercials featuring Federer played and replayed on changeovers on the big-screen televisions inside the arena. Wawrinka even looked up from his chair and watched on occasion." In 2017 he told a reporter who asked about Federer, "I have been asked about him for ten years, I can answer if you want but I am a little bit tired."

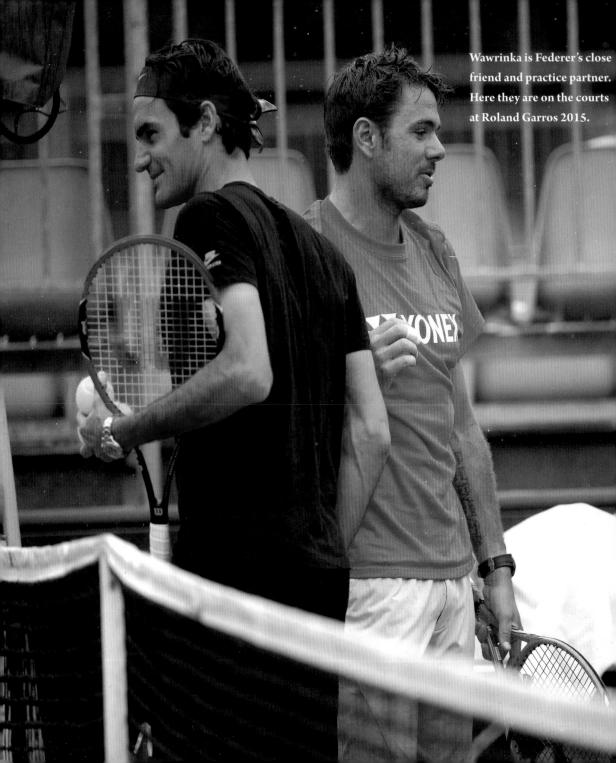

Wawrinka is Federer's close friend and practice partner. Here they are on the courts at Roland Garros 2015.

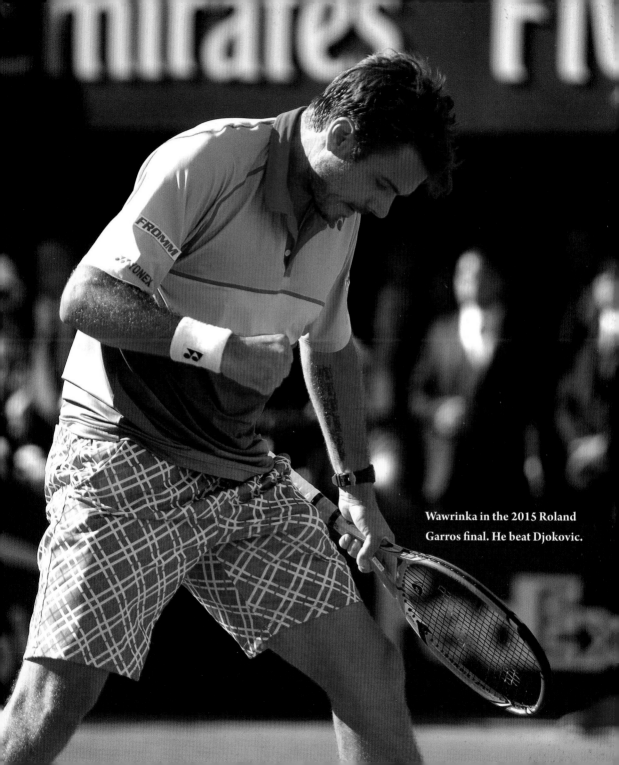

Wawrinka in the 2015 Roland Garros final. He beat Djokovic.

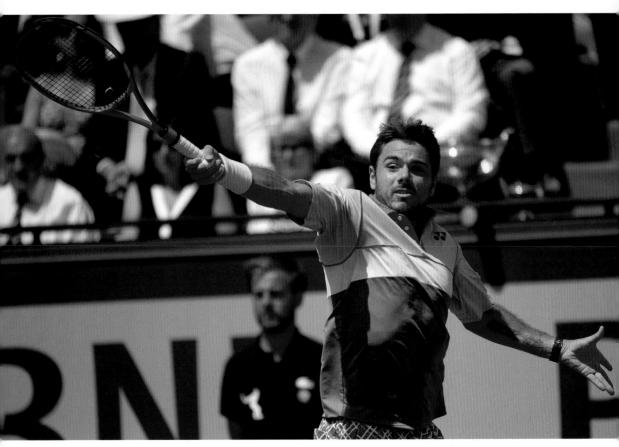

Wawrinka's single-handed backhand is considered one of the best in modern tennis. This photograph was taken at Roland Garros 2015.

Some years ago Wawrinka got rid of his difficult first name, "Stanislas." Now he likes to be known simply as "Stan." A 2015 profile in the *Atlantic* magazine, written after he had won Roland Garros, described Stan this way: "From his bright pink 'pajama' shorts to his faintly dadboddish physique, the Swiss native looks more like someone you'd find at Home Depot than Roland Garros." But then it went on to call his tennis "mind-blowingly beautiful." In particular, his highly successful single-handed backhand, laden with topspin, is celebrated. Michael Steinberger of the *New York Times* described the single-handed backhand in general as "a singular display of agility, balance and precision timing" and "the last redoubt of artistry in tennis, a final vestige of the sport as it was traditionally played." Wawrinka shares the shot with Federer (and others, including Richard Gasquet, Grigor Dimitrov, and Dominic Thiem), but arguably Wawrinka's is the best.

Stan is no longer the underdog, although statistically he can never catch up with Federer, Nadal, or Djokovic. After the 2016 US Open, the *Economist* magazine called him the "great latecomer" and asked whether he was "a thwarted all-time great, or a mere supporting act." Wawrinka is only a Wimbledon victory away from a career singles Grand Slam, something achieved so far by only seven male players (Fred Perry, Don Budge, Rod Laver, Roy Emerson, Andre Agassi, Roger Federer, Rafael Nadal, and Novak Djokovic). But despite winning the 2014 Australian Open, where he beat Nadal in the Finals; the 2015 French Open, where he beat Djokovic, denying him a career Grand Slam that year; the 2016 US Open, where he beat Djokovic, who deemed him "the more courageous player in the decisive moments;" the gold medal in doubles at the 2008 Beijing Olympics (Federer was his partner); and the 2014 Davis Cup doubles tournament, Wawrinka still seems to remain in the shadow of his friend and fellow Swiss, the sublime Roger Federer. In the 2017 Australian Open semifinal, in a very tough match, Federer beat Wawrinka in five sets (and then went on to beat Nadal in the final).

Some of the credit for Wawrinka's emergence goes to his widely admired coach from 2013 to late 2017, Magnus Norman, former World No. 2 (in 2000), sometimes called "The Tennis Whisperer," and often described as the world's best tennis coach. Norman, who is known for working on mental attitude first and foremost, never won

In 2015 Wawrinka surprised almost everyone by winning Roland Garros. In the finals he defeated Djokovic, the favorite.

a Grand Slam himself; the furthest he got was the French Open final, where he lost to the Brazilian Gustavo Kuerten. Wawrinka told the *New York Times:* "Magnus is telling me to be more aggressive, try to push more with my forehand and the serve, but of course my game is still more or less the same. You can't change your game at 28, it's just trying to improve what you have. Sometimes I'm hesitating about things because I'm not feeling confident. That's what I'm trying to change." Wawrinka was shocked when (apparently for family reasons) Norman decided to quit in late 2017: "It was a big disappointment. A shock. In some of the worst moments of your career, you expect to be able to count on your dear ones."

After Wawrinka won the US Open, the TV interviewer Charlie Rose asked him, "Can you be number one?" Wawrinka laughed. "No," he said. Then he added, with a shrug, "I'm not consistent enough. I don't play well enough during the years. You play tennis week after week." Many commentators have observed that although Wawrinka, whose tattoo on his inner left forearm features a well-known quotation from Samuel Beckett's *Worstward Ho* ("Ever tried. Ever failed. No matter. Try Again. Fail again. Fail better."), can rise to the occasion in big matches, his average level of performance is often mediocre. Wawrinka himself has said, "The Big Four, I'm really far from them." Perhaps that explains the 2017 Roland Garros final when Nadal destroyed Wawrinka in straight sets. And then, shortly afterward, 2017 Wimbledon, the pity of it, Wawrinka lost in the first round to Daniil Medvedev, ranked No. 49. "Pathetic," said one commentator. And then, at the beginning of August, Wawrinka called it quits for 2017. "I am sad to announce that after talking with my team and doctor I had to make a difficult decision to undergo a medical intervention on my knee." As of the end of 2017, Wawrinka is ranked No. 9.

After beating Djokovic in the 2015 French Open (it is said that Wawrinka is the player Djokovic fears the most), Wawrinka told the *Daily Telegraph* that he had suffered a hangover of the soul. "Afterwards, you feel a little bit lonely, a bit of depression mentally. Because it's so much stress and emotion, so many people around—and then it's completely empty." As John Jeremiah Sullivan wrote in his introduction to David Foster Wallace's *String Theory*, tennis "draws the obsessive and the brooding. It is perhaps the most isolating of games."

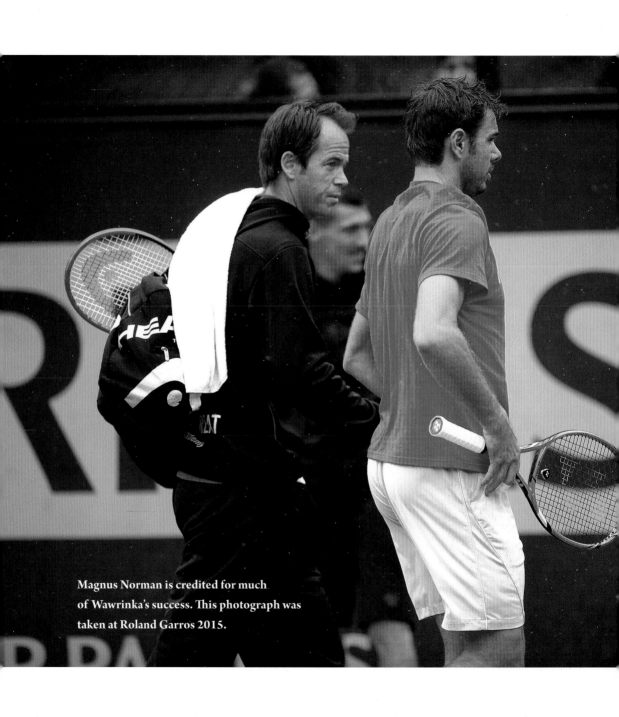

Magnus Norman is credited for much of Wawrinka's success. This photograph was taken at Roland Garros 2015.

**Struggling with consistency, Wawrinka
sometimes plays at a level that is embarrassing
even to himself—Rogers Cup 2016.**

Juan Martín del Potro

Star? Or Tragic Story?

He's six-and-a-half feet tall. He's rangy, like a hero in a Western movie. He walks slowly and purposefully at changeovers. He's been called the gentle giant. He has been described as shy, self-effacing, diffident, lacking in self-confidence. He has been plagued by injuries. He's suffered intolerable physical setbacks—intolerable for anyone else. But Delpo, as they affectionately call him, has persevered. He has not given up. His big, devastating, forehand (Novak Djokovic has called it "lethal") has survived multiple wrist surgeries (one on his right wrist, three on his left). His two-handed backhand has not; it is a shadow of what it once was.

Is del Potro a star, or a tragic story? Is he an unlucky giant of the game, or an also-ran who happened, as a very young man, to play one great tournament, the 2009 US Open? In June 2016 the *New York Times* described him as "the great lost talent of this bright and shiny tennis decade." Said the newspaper: "If you mention Juan Martín del Potro to most of the game's leading men, their expressions do not lie. There is usually a slight wince, sometimes even a full shake of the head. There is genuine, unmistakable sympathy and the feeling that no champion . . . deserves to have to deal with this."

By the way, del Potro is not always gentle. Jacob Steinberg in the *Guardian* newspaper has described "the bloodcurdling, guttural snort from Juan Martín del Potro whenever he unleashes one of the trademark bone-crunching forehands . . . a snort so dismissive that it could earn him the role of most terrifyingly muscle-bound henchman in the next James Bond film. With his mighty 6ft 6in frame, the hulking Argentinian would look and sound the part." And he can be bad-tempered. In 2008 he is said to have insulted Andy Murray's mother at a changeover in Rome. Murray reacted badly in what became known as the "Mamma mia" incident. "I wasn't great friends with him before," said Murray afterward. "I don't need to be friends with him now." On another occasion, at Wimbledon in 2016, del Potro and the Frenchman Lucas Pouille

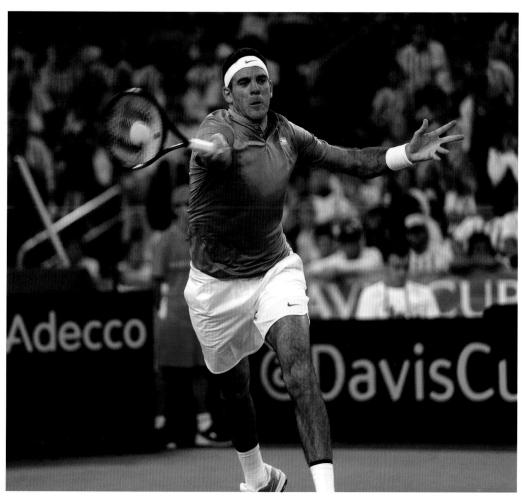

Del Potro has one of the most accomplished forehands on the ATP Tour.

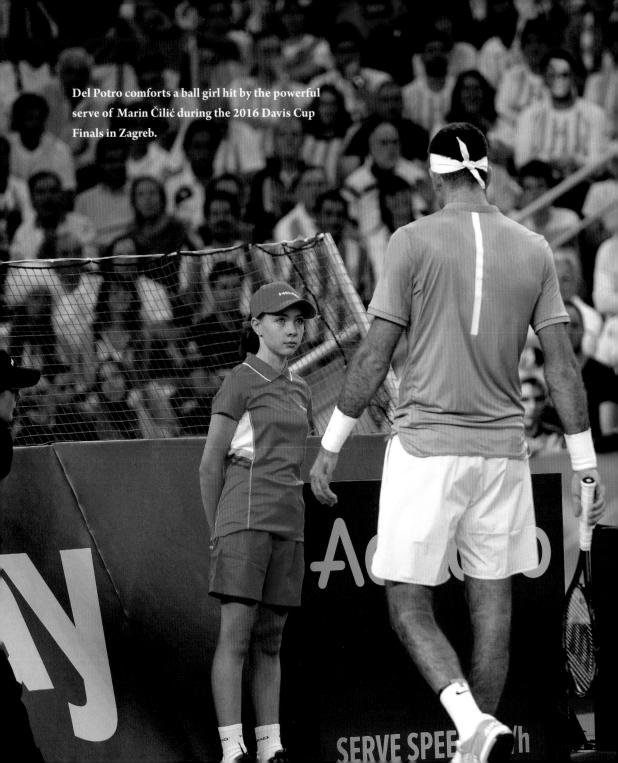

Del Potro comforts a ball girl hit by the powerful serve of Marin Čilić during the 2016 Davis Cup Finals in Zagreb.

exchanged angry words in a match marked by unusual ill will and tense looks. At one point, Del Potro told Pouille to "shut up." (Pouille won the match.)

But incidents like these are few and far between. Del Potro's essential nature is gentle and playful. He hams it up with the spectators, particularly when he has lost a close point. The consensus is that he's one of the most likable players on the tour. At the 2016 Davis Cup he comforted a ball girl accidentally hit by a Marin Čilić serve. That was typical Delpo. At 2017 Roland Garros, he comforted Nicolás Almagro after Almagro burst into tears when he had to withdraw in the third set because of a left knee injury. The *New York Times* reported: "As they walked together toward their chairs, Almagro, still disconsolate, turned back to embrace del Potro. When Almagro sat down in his chair and again put his head in his hands, del Potro sat down next to him, rubbed his head and tried to say consoling words." *Sports Illustrated* called what de Potro did "the true definition of sportsmanship."

So how did this great sporting figure find his way onto the big stage? Juan Martín del Potro, an Argentinian, son of a veterinarian, and devout Catholic, achieved a place in the ATP Top 10 in October of 2008, but wasn't considered a top contender because he was still a teenager (just). Things changed dramatically at the 2009 US Open, his moment of glory. At twenty years old, to general surprise, del Potro won the title, defeating Roger Federer in the final. (As if it mattered, commentators, trying to find something interesting to say, noted that he was the tallest person ever to win a Grand Slam.)

Del Potro had the world at his feet. In January of 2010, going into the Australian Open, he was ranked No. 4 in the world. But after the 2010 Australian Open, where Marin Čilić beat him in the fourth round, he had to pull out of the tour because of a left wrist injury. In May, he had surgery. He hoped for a speedy recovery, saying that he would defend his US Open title in September. But after only two weeks of practice in August, and recurring problems with his wrist, he decided not to play in New York. The year 2010 was depressing and unfruitful for Juan del Potro. In early 2011 he had to rely on wild cards to enter tournaments. Following a second-round defeat in the 2011 Australian Open (by Marcos Baghdatis), his ranking slipped to No. 485.

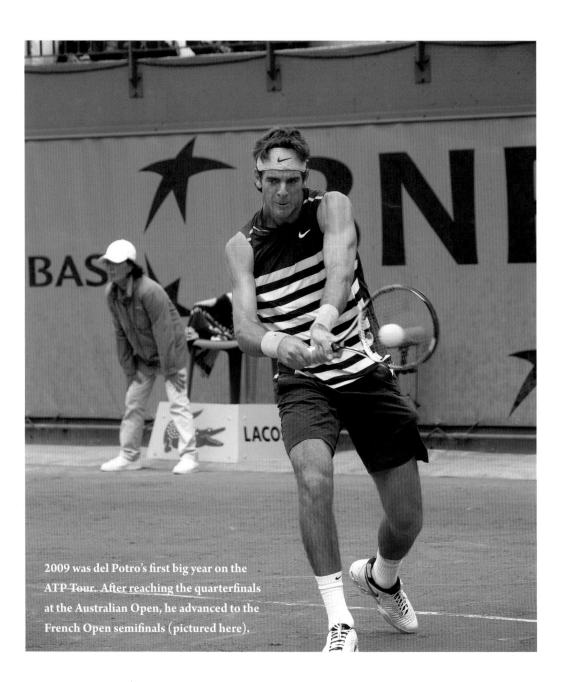

2009 was del Potro's first big year on the ATP Tour. After reaching the quarterfinals at the Australian Open, he advanced to the French Open semifinals (pictured here).

But then he started a steady climb back, winning in Delray Beach (February) and Estoril (April) and doing well in other tournaments. Del Potro finished 2011 ranked No. 11 and was named 2011 ATP Comeback Player of the Year. In 2012 he continued to do well, again winning Estoril, and three other titles, and beating Roger Federer in Basel. He ended the year ranked No. 7. By 2013, del Potro was ranked No. 5. At Wimbledon he reached the semifinals. All seemed well. Delpo was back.

Then came calamity. In 2014, after winning the first round at the Australian Open, del Potro had more problems with his left wrist and was beaten by Roberto Bautista Agut in the second round. He had surgery in March and skipped the rest of the season. His second comeback, in 2015, was highly anticipated and ended almost before it began. In January, he reached the quarterfinals in Sydney. Next stop the Australian Open, but del Potro decided to take another break from tennis. "My wrist is bothering me again and I have to fix this problem," he said in a press conference. He had surgery in June 2015. By January 2016 his ranking had dropped to a stunning 1,041. How could he recover? He thought of giving up tennis, perhaps to study architecture, a subject that had long interested him.

But by April 2016, in his third comeback, del Potro had clambered back up to an astonishing No. 166. In the June Olympics, he won the silver medal, beating Djokovic (who burst into tears when he lost) and Nadal. He reached the quarterfinals in the US Open. In November he led Argentina to a Davis Cup championship; his home country was ecstatic at winning the Davis Cup for the first time ever. He gave his medal to his grandfather, Francisco Lucas, who passed away in May 2017. In a Facebook post, del Potro thanked him for leading the way with his "humility and fighting spirit." Exhausted after his Davis Cup effort, he decided not to play in the 2017 Australian Open.

By February 2017 he'd climbed to No. 32. Del Potro, "desperate for a second act" as one journalist put it, was definitely back. The *New York Times* wrote: "At 28, del Potro has found a tennis contentment he never thought possible when he was home in 2015, watching *The Simpsons* and *Breaking Bad* on television instead of playing tennis." Many have said that del Potro's dramatic 2016–2017 return to the tennis courts is a greater achievement than Federer's astonishing 2017 renaissance.

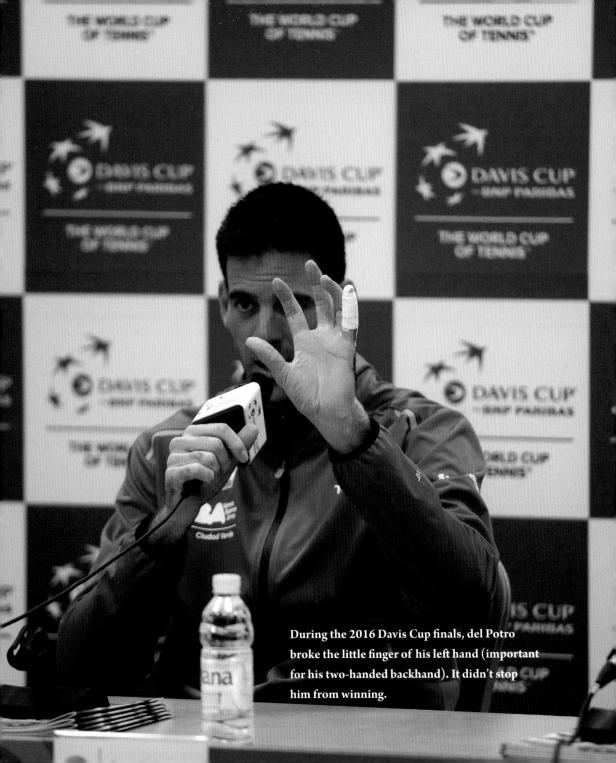

During the 2016 Davis Cup finals, del Potro broke the little finger of his left hand (important for his two-handed backhand). It didn't stop him from winning.

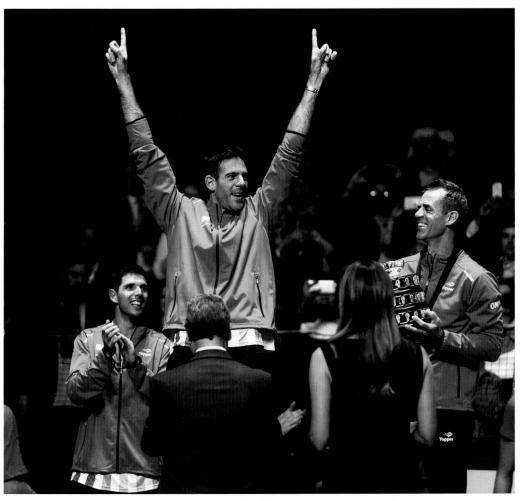

Del Potro was the key to Argentina's first-ever Davis Cup title. He beat Andy Murray in the semifinals, then Marin Čilić in the finals after being down two sets to love.

But at Wimbledon 2017, del Potro was beaten in the second round, in straight sets, by Ernests Gulbis, ranked No. 589.

Then came the 2017 US Open. In his fourth-round match against Dominic Thiem, del Potro lost the first two sets. Louisa Thomas of the *New Yorker* wrote it was at that point that she turned off the television and went to dinner. She described what happened after that: "I missed the greatest comeback of the year—a 1–6, 2–6, 6–1, 7–6 (7–1), 6–4 thriller. I missed del Potro erasing two match points, and the thunderous ground strokes that drove Thiem back during the tiebreaker in the fourth set. I missed the New York crowd chanting '*Olé!*,' and del Potro flinging his arms out as if to embrace it." The journalists raved: "Unforgettable," "The stuff of legend," "Magic." Then, del Potro beat Roger Federer in four sets in the quarterfinal (one wag commented, "he killed Bambi"). Del Potro lost to Nadal in the semifinal, but the tennis world won't forget his victory over Thiem and Federer. *Olé!*

At the end of 2017, del Potro was ranked No. 11 in the world.

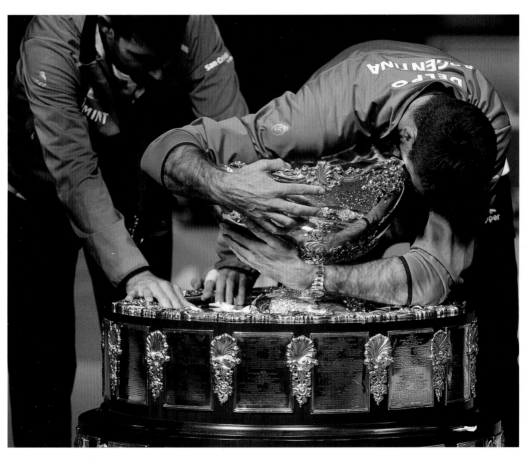

Del Potro at his happiest—with the 2016 Davis Cup trophy.

Gaël Monfils

"I'm ready to die for that, to win a Slam."—Gaël Monfils

On the court, Gaël Monfils is elegant, beautiful, and supremely athletic. He slides, slips, leaps, dances, tumbles, dives, laughs, and yells. "La Monf" (a nickname—another is "Sliderman") moves like lightning. He seems able to return any ball, no matter where it goes and no matter how it gets there. As Ben Austen wrote in the *New York Times Magazine* in August 2017, "He is a player who crackles with the possibility that, at any instant, he may do something beyond the limits of physical laws or human capabilities or merely the respectable conventions of tennis."

Nodding their heads and wagging their fingers, the tennis gasbags say, "He may be a brilliant athlete, but he is lazy, tactically weak, erratic, passive, petulant, exasperating, and a show-off." "La Monf is a punk," says one. "He is a troubled genius," says another. "He plays to the crowd." "He's more interested in entertaining than playing tennis. "Andy Roddick, onetime World No. 1 and 2003 US Open champion, has said that Monfils "Showboats when winning and rolls over when down." When he played Djokovic in the 2016 US Open semifinal (he lost), one news account described his stance when receiving a serve as "looking like someone waiting in line to place his take-out espresso order." Former Top 10 player Henri Leconte said in 2012 that Monfils "is completely lost." But, added Leconte, "Beware if the beast awakes."

His career has been erratic in the extreme. In 2011 Monfils was ranked No. 7 in the world. In early 2013, following months of being sidelined by injury, he dropped into professional tennis purgatory, ranked below a hundred. He went into 2013 Roland Garros at No. 81, and by the end of the tournament had clawed his way up to No. 67. "I never check the rankings," he says, but no one believes him. All tennis players check the rankings. By Wimbledon 2015, his career partially revived, Monfils was ranked No. 18. At the beginning of 2017 he was back to No. 7. By April he had dropped ten places, to No. 17. At the end of November he was No. 46. He has never been in a Grand Slam final.

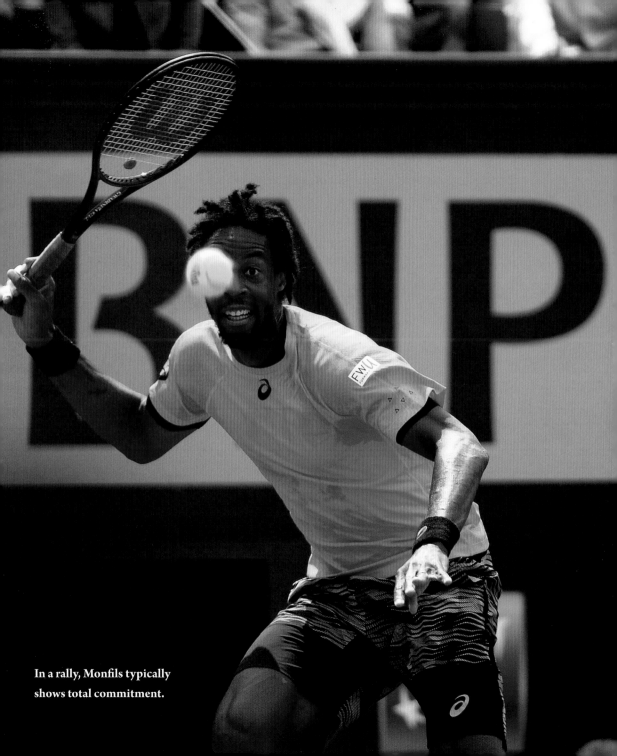

In a rally, Monfils typically
shows total commitment.

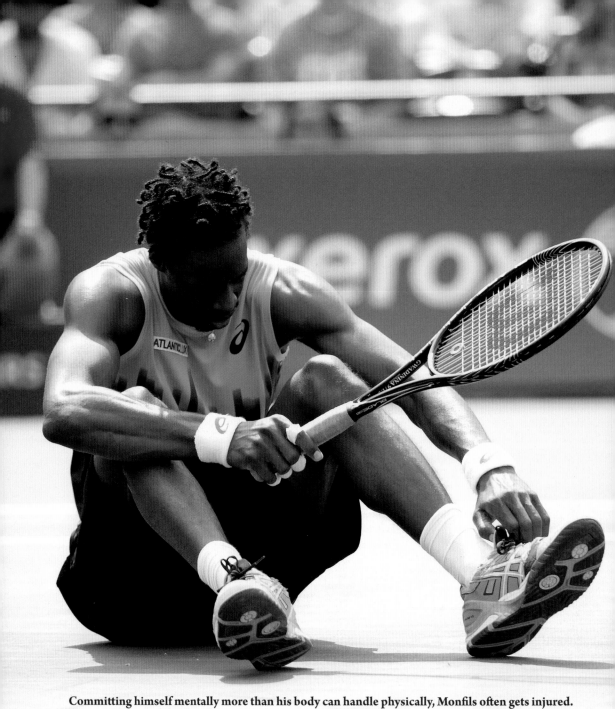

Committing himself mentally more than his body can handle physically, Monfils often gets injured.

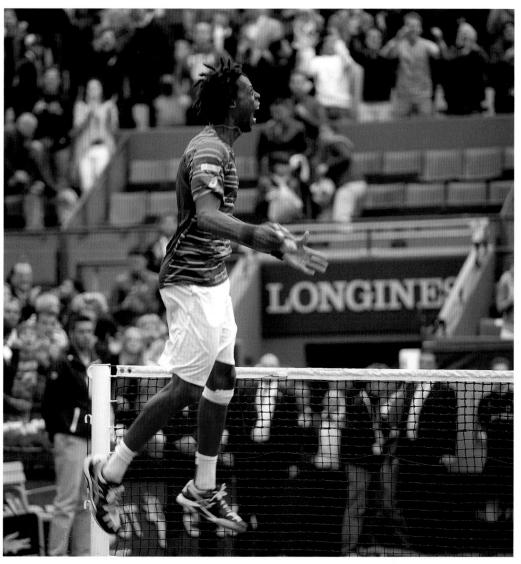

Monfils is one of the most expressive tennis players on the ATP Tour. This photograph was taken at Roland Garros 2015.

He is, it seems, always injured. He has injured his knees, hips, back, hamstrings, leg, ankle, shoulder, groin, abdomen, wrists, and stomach. He has retired from matches in Bucharest (2013), Madrid (2011 and 2006), Stuttgart (2010), Shanghai (2009), Australia (the 2009 Open), Cincinnati (2008), Rome (2008), Szczecin (2007), Monte Carlo (2007), London (2006), and Bastad (2005). He has failed to start a match (called a "walkover," with victory awarded to the player who shows up) in San Jose (2011), London (2009), and Rimini (2004). He missed several months in 2012 because of a right knee injury. He dropped out of the 2015 Miami Open (hip). In 2016 he skipped Roland Garros (virus), the Paris Masters (rib), and the Davis Cup quarterfinal (knee), and pulled out of ATP World Tour Finals in London (rib). In 2017, he withdrew once more from Miami, from the Davis Cup quarterfinal (knee and Achilles tendon), and retired during his third-round match at the US Open. The French Davis Cup captain, Yannick Noah, has said of Monfils that there is a "lack of investment," that Monfils gives priority to his "personal goals," and that he "needs to prove he is really motivated." He is said to suffer from periodic depression. Some of this, presumably, is the price he pays for his extreme physicality.

From time to time, the career of Monfils seems to be in tatters, yet he always claims not to be worried. He frequently describes himself as very relaxed. He has won about $13 million in prize money. His ambition, he says, is to win the French Open, to hoist the Coupe des Mousquetaires, but it now looks increasingly unlikely that Monfils, who was born in Paris in 1986, will be the French player to revive the glory days of Yannick Noah, winner of Roland Garros in 1983, the last Frenchman to win in singles at that tournament. At the 2015 French Open, Monfils was easily beaten by Roger Federer in the fourth round. In 2016, he didn't compete (he had a virus). In 2017, Stan Wawrinka beat him, again in the fourth round.

John McEnroe, once a bad boy himself, and famous for temper tantrums on the court and berating officials, once went into a tirade on television about Monfils. It occurred during the first round of the 2013 French Open when Monfils (who, in his eighth French Open, this time needed a wild card to enter the tournament), played Tomáš Berdych, a Czech seeded fifth. According to McEnroe, the French had stopped believing in Monfils, and that was why the stadium was only half-full.

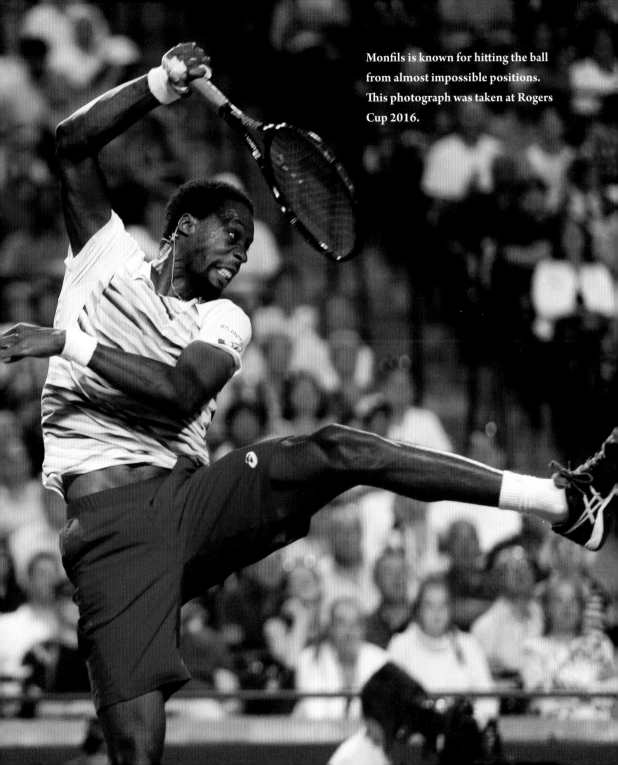

Monfils is known for hitting the ball from almost impossible positions. This photograph was taken at Rogers Cup 2016.

He said Monfils was unable to embrace competition; had a fear of failure; could not deal with the ups and downs of the game; had a hard time emotionally; had completely slipped off the map; waited for the other player to lose the point, rather than trying to win one; had had at least eight coaches, and that his various coaches were fed up with his low commitment level. But the stadium filled up, and Monfils played brilliantly against Berdych. By the end of the match, which lasted four hours, McEnroe had changed his tune. "Marvelous first-round tennis," he said. The *New York Times* tennis blog commented, "Gael Monfils summoned the magic of Court Philippe Chatrier. . . . Monfils served extraordinarily well. . . . Monfils held serve by managing his service game to near perfection." Monfils beat Berdych in five sets, 7–6, 6–4, 6–7, 6–7, and 7–5. "It's magic here," he said at the press conference following the match. "This victory is beautiful."

It wasn't the only time that McEnroe had something to say about Monfils. In the second round of 2013 Roland Garros, Monfils played the Latvian Ernests Gulbis. At the beginning of the game, McEnroe said Monfils's entertainment value is high and his predictability value low and that he expends far too much energy early on, and then has nothing left. Of a Monfils serve, McEnroe said, "That's one of those 'I just don't want to double-fault' serves." When Monfils seemed to hobble a bit, McEnroe commented, "It's a good time to try and get a little sympathy." But once again, Monfils played superbly and beat Gulbis in four sets, after dropping the first. The *New York Times* said, "the quality of the exchanges was routinely spectacular, with the most eye-catching material coming when Gulbis flexed his muscles and Monfils stretched and stretched his elastic limbs and absorbed all of that controlled fury." The *Guardian* was eloquent: "Something special illuminated the eddying gloom of Roland Garros on Wednesday. Over three and a quarter hours, Ernests Gulbis, a Latvian of volcanic temperament, and France's elastic magician, Gaël Monfils, enthralled the patrons of Court Philippe Chatrier with tennis that encompassed all the arts, from touch to power." In the third round, Monfils, despite having four match points, was defeated by the Spaniard Tommy Robredo, 2–6, 6–7, 6–2, 7–6, 6–2. "This is unbelievable!" said McEnroe.

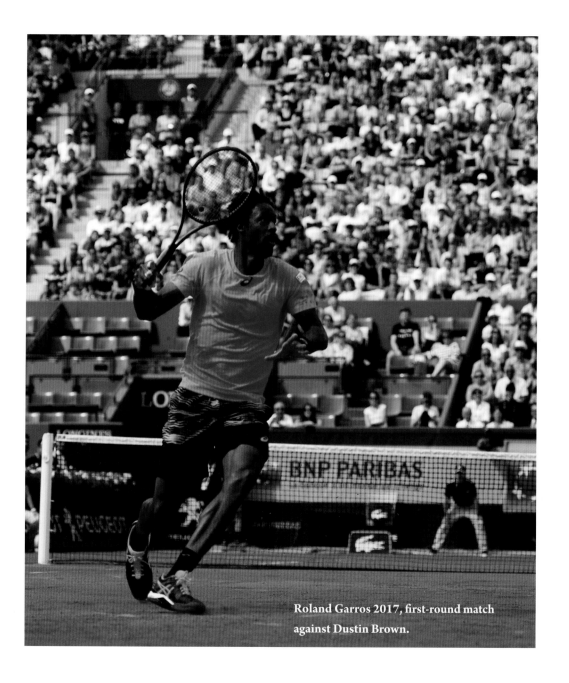

Roland Garros 2017, first-round match
against Dustin Brown.

How to sum up Gaël Monfils? Many words have been used to describe the ener-
getic player who sports tattoos of the islands of Guadeloupe (father's origins) and
Martinique (mother's origins) on his arms—brilliant, naughty, a maverick, mind-
boggling, incomparable, fun, kind, gracious, erratic, and comic. At his best, he is
probably as good as they get. At the end of 2017 he told a journalist, "My goal is still
to win a Slam, you know. I'm working for that and I'm ready to die for that, to win
a Slam."

Marin Čilić

"I think it's just bad luck."—Jonas Bjorkman

Roger Federer easily beat Marin Čilić at the Wimbledon 2017 men's final, 6–3, 6–1, 6–4 (Čilić was suffering from a bad blister on his left foot). During a changeover break, down a set and two games, sitting in his chair, Čilić burst into tears and then put a towel over his head. Later, Čilić's coach, Jonas Bjorkman, said, "That's how it goes. It's a long season. I think it's just bad luck."

Čilić, a six-foot-six Croatian, born in 1988, first attracted serious international attention when he won the 2014 US Open, beating his 2017 Wimbledon nemesis, Roger Federer, in the semifinal, and easily beating Kei Nishikori in the final. (Federer has said that his defeat by Čilić was one of his most devastating career losses.) Before that big win, there was not a lot of interest in Čilić. Juan José Vallejo in *Rolling Stone* magazine had described him as "one of those pros who ambled around reminding us just how promising they once were, and how they had fallen short trying to fulfill all that potential."

And then there was his 2013 drug problem. Čilić tested positive for a banned substance and was given a nine-month suspension, reduced on appeal to four months by the Court of Arbitration for Sport (he had accidentally ingested small traces of a banned substance when taking an over-the-counter supplement, or at least so the story goes). As a result of the suspension, in 2013 Čilić missed the French Open and Wimbledon. He still feels a lingering bitterness over what he believes was shoddy and unfair treatment. Not everyone was sympathetic to his plight, though. Andy Murray accused Čilić of being "unprofessional" for not checking the contents of the over-the-counter supplement. Federer was skeptical of Čilić's behavior and explanation.

Perception changed with the big 2014 US Open win. On *Charlie Rose* the day after his victory, Čilić, fluent in English, was likable, modest, and smart. He told Rose he had developed a belief in himself, was no longer obsessed by tactics, and had become "dangerous" as a player. He gave much of the credit to his coach from 2013 to 2016,

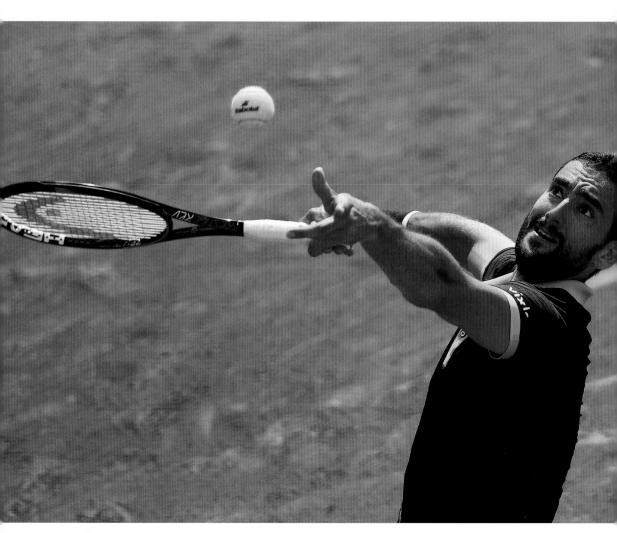

Roland Garros 2016.

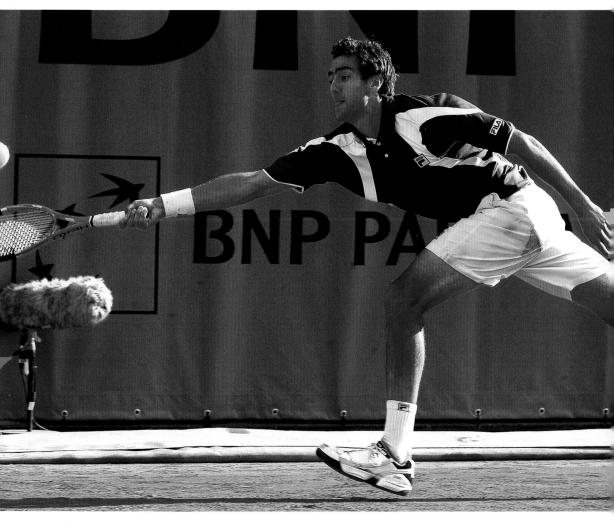

Roland Garros 2015.

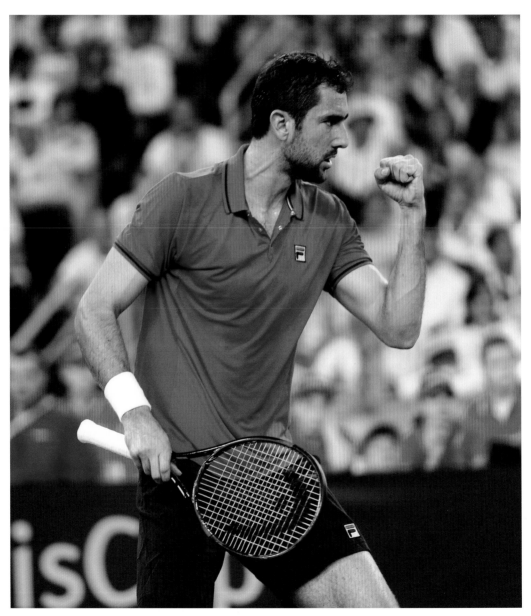

An aggressive Čilić at the Davis Cup in Zagreb, 2016.

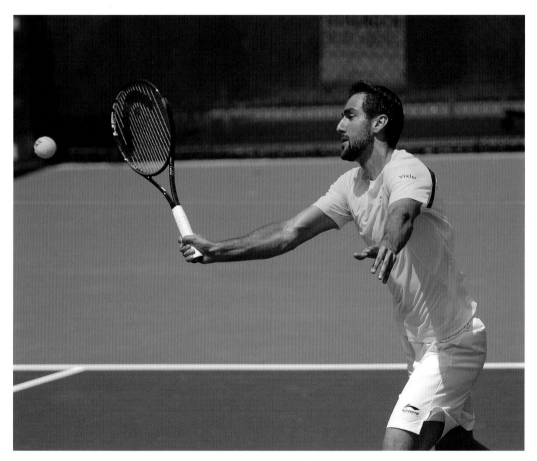

On the practice courts at Rogers Cup 2016, working his way back to the top.

fellow-Croat Goran Ivanisevic, who won Wimbledon in 2001 and who urged Čilić to be more aggressive.

There are, however, limits to how aggressive he is prepared to be. Čilić, it seems, is a gentleman. In an interview just before Wimbledon 2017, he said, "People are asking always, 'Do you need to be more arrogant? Do you need to be more angry on the court, to be more selfish or stuff like that, to be able to win more constantly?' For me, I wouldn't agree. There is not one formula for that."

After his 2014 US Open victory, Čilić arguably went back to being one of those pros who amble around reminding us just how promising they once were. Suffering from a shoulder injury, he missed the 2015 Australian Open. He lost in the fourth round at the 2015 French Open and a little while later lost in the quarterfinals at Wimbledon. At the 2015 US Open, Čilić was easily beaten by Djokovic in the semifinal, 6–0, 6–1, 6–2, in eighty-five minutes. At the 2017 ATP Finals, Federer reprised his earlier Wimbledon victory over Čilić (although Federer dropped the first set of the ATP Finals match against Čilić in what proved to be a tougher match than Wimbledon). But the story is not over yet. In November 2017, Čilić was ranked No. 6 (for a few days he reached No. 4), ahead of Djokovic, Wawrinka, Nishikori, and other long-established top-20 players.

Federer beat Čilić again at the 2018 Australian Open final, but that was a much tougher five-set fight for Federer—6–2, 6–7, 6–3, 3–6, 6–1. Until the fifth set, it looked as if Čilić might win. After the final, Čilić was ranked No. 3 in the world. He's not waiting in the wings, not anymore. He's moving to center stage. Maybe his luck has finally changed.

Kei Nishikori

"It is difficult in Tokyo. I have to wear sunglasses,
a hat, a mask, everything."—Kei Nishikori

Kei Nishikori is the first Asian to reach a Grand Slam singles final. It was the 2014 US Open. He lost, badly, to Marin Čilić. But, to get to the final, he beat Milos Raonic and Stan Wawrinka in marathon matches, and then Novak Djokovic in the semifinal. "This is definitely huge for Japan," said Djokovic afterward. Nishikori is now famous in Japan, a superstar. "It is difficult in Tokyo," he says. "I have to wear sunglasses, a hat, a mask, everything."

Nishikori was the first Japanese man in eighty-one years to compete in a Grand Slam singles semifinal. His predecessor was the brilliant Jiro Sato, once ranked No. 3 in the world, who reached five major semifinals, including Wimbledon in 1933. In 1934, feeling under pressure from the Japanese tennis establishment and struggling with depression, Sato threw himself off the side of a ship on his way to the Davis Cup in England and drowned. Nishikori is sometimes described as "un-Japanese" in the way he thinks and behaves. Learning, perhaps, from the Sato tragedy, he has developed a strong belief in individuality rather than the collectivity.

Nishikori was born in December 1989 in Matsue, population about 200,000, the capital city of Shimane Prefecture in the Chūgoku region of the main Japanese island of Honshu. When he was five, his father, an engineer (his mother is a piano teacher), casually gave him a children's tennis racket. Neither of his parents played tennis or had any real interest in the sport, but it was clear from the start that Kei was a natural. He began by hitting balls against the garage wall. Within twelve months, his parents had enrolled him in a local tennis school.

Nishikori, who now spends little time in his home country (despite his fame in Japan, or perhaps because of it), left home at fourteen to train at the IMG Academy in Bradenton, Florida. He turned professional in 2007 and in 2008 won his first ATP Tour event, Delray Beach, beating James Blake in the final, and reached the fourth round of the US Open. In 2013 he hired Michael Chang as his coach. Chang was a former World No. 2

43

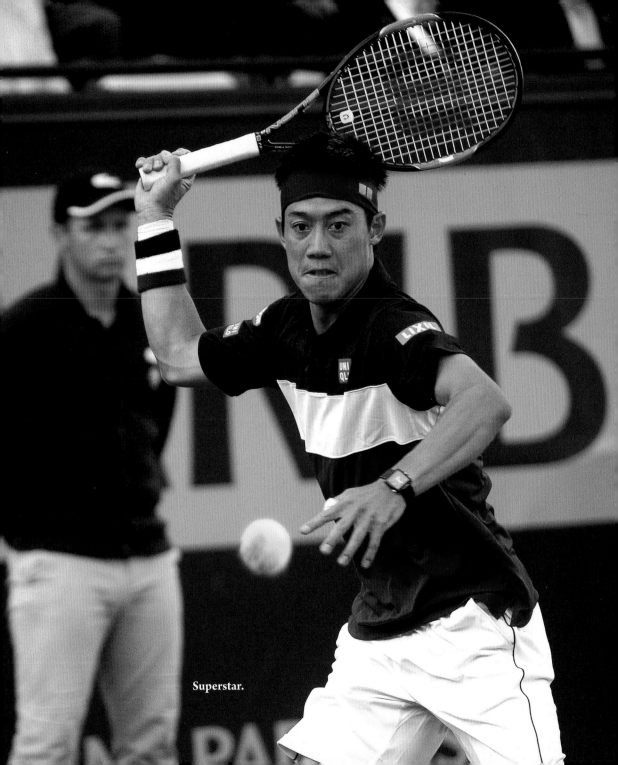

Superstar.

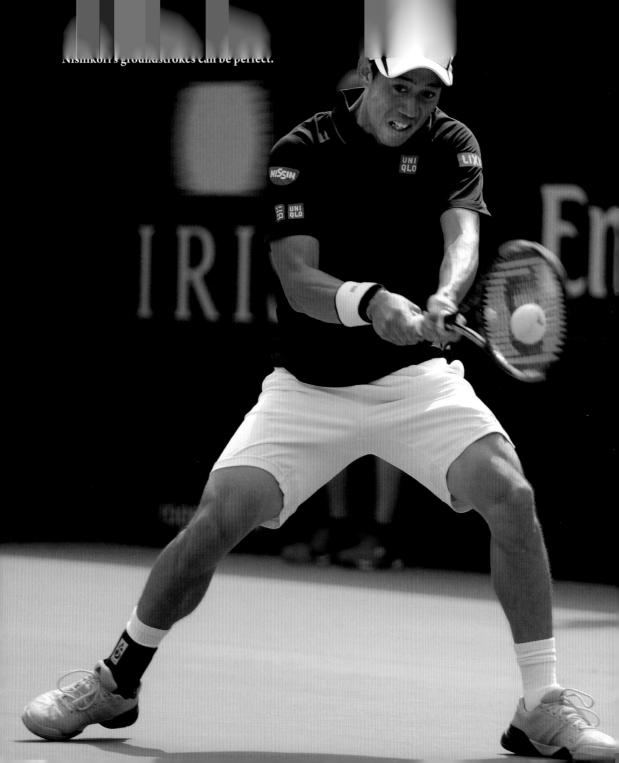

Nishikori's groundstrokes can be perfect.

and the 1989 French Open champion. By March 2015 Nishikori was World No. 4, the highest ranking he has so far reached (at the end of 2017 he was ranked No. 22).

Louisa Thomas wrote in the *New Yorker* magazine in 2016 that Nishikori "is one of the most dynamic shot-makers on tour, fast and agile, with perfect strokes and incredible hands." Writing for *Grantland* the year before, Thomas described Nishikori's groundstrokes as near perfect and his backhand and returns as his "weapons." She explained, "He had quick, light feet; excellent balance; and a rare sense of where the ball would be. . . . He had startling power—fluid and natural."

But Thomas and other Nishikori watchers also have their reservations. They point out that he is too short, too light, and too fragile (five-foot-ten and 150 pounds) in a sport that favors the tall and the muscular and the tough. "He had a reputation as a grinder, a counterpuncher who could be overpowered," writes Thomas. "Maybe his small frame really was too delicate for the strain he put on it." Nishikori withdrew from 2017 competition in August and spent the rest of the year nursing debilitating wrist injuries.

After his 2014 US Open near-triumph, the *New York Times* ran a long story about Nishikori. One person they interviewed was his coach and teacher Dante Bottini. "In the airport, he's always behind," Bottini said. "We are always looking for him and going, 'Where is he?' He's so slow that it irritates me sometimes, but if he wants to save the energy for the matches, that's fine with me."

Nishikori is nervous. He feels the breath of the new generation on the back of his neck. In November 2017, Nishikori told the *Japan Times*: "Seeing Zverev definitely made me feel old. It's rare to see a player that young play so well nowadays. I know I'm not considered a young player anymore. Of course, I feel pressure in that sense but that's the reality."

The pressure of being a top athlete expected to win.

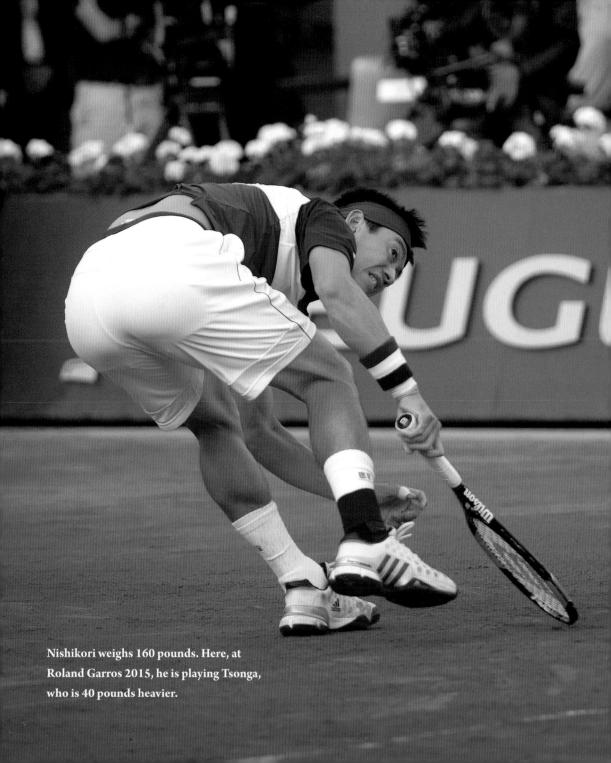

Nishikori weighs 160 pounds. Here, at
Roland Garros 2015, he is playing Tsonga,
who is 40 pounds heavier.

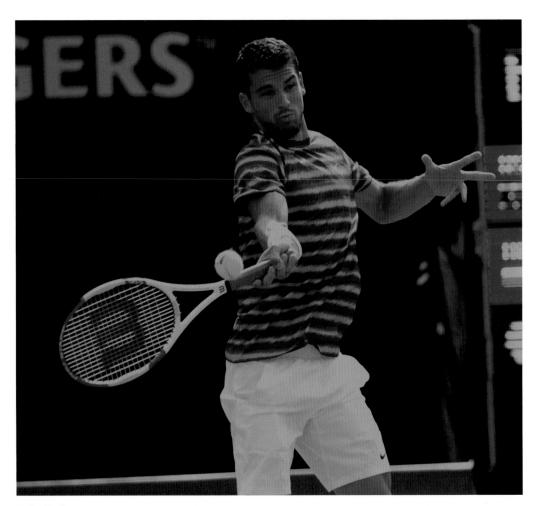

Baby Fed.

Grigor Dimitrov

"You're human, you're playing tennis, so why not
you one day?"—Grigor Dimitrov

He's Bulgarian, born in 1991 in Haskovo, a hardscrabble town. His first coach was his father, Dimitar, a professional tennis coach, one of few in Bulgaria, where Grigor is now considered a rock star (though he lives in Paris). He says his main interests, apart from tennis, are extreme sports, cars (he owns a fleet of very expensive automobiles, including a scissor-doored Mercedes SLS), computers, and watches. He says he paints and designs clothes. He likes racing motorcycles and dancing. He's dated tennis superstars Serena Williams and Maria Sharapova. His girlfriend as of late 2017 is pop singer Nicole Scherzinger, who was born in 1978.

People say Dimitrov reminds them of a young Roger Federer, mostly because he covers the whole court with great ease and fluidity and has a beautiful one-handed backhand. For a time he was known as "Baby Fed." (He's also been called "Showtime," "Primetime," and the tour's "Reigning Adonis.") In 2008, in Rotterdam, he beat Tomáš Berdych, and took a set off Rafael Nadal. Later that year, he won the junior title at Wimbledon and the US Open, and tennis watchers started to pay attention. In 2009, his then coach, Peter Lundgren, who earlier had been Federer's coach, said, "He is better than Federer was at his age."

Dimitrov's career has been up and down, but recently it's been up. In 2017 he defeated Dominic Thiem, Milos Raonic, Kei Nishikori, David Goffin, Nick Kyrgios, Fabio Fognini, and Juan Martín del Potro. In November 2017, he beat David Goffin to win the ATP finals (they were both first-time ATP finalists). Kevin Mitchell wrote in the *Guardian*, "they brought freshness and daring to a task that has historically been fulfilled by more illustrious rivals." The president of Bulgaria sent congratulations. Dimitrov has never defeated Federer, most recently losing to him at the fourth round of Wimbledon 2017 in straight sets. At the end of the 2017 season he was ranked world No. 3, just behind Federer. His career earnings are more than $13 million.

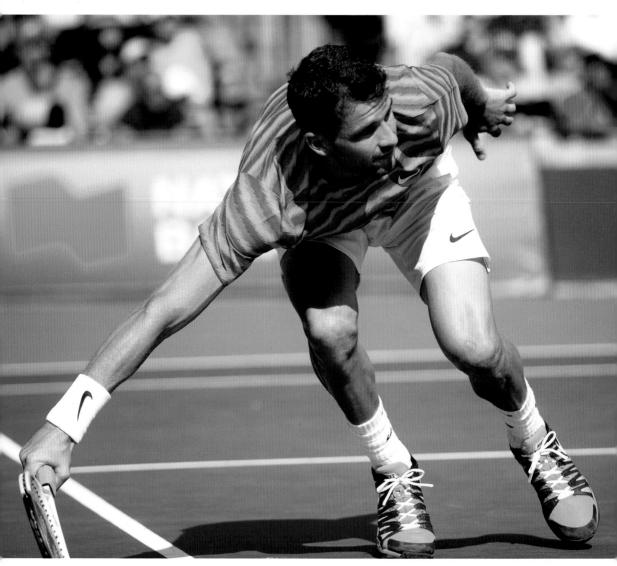

Freshness and daring.

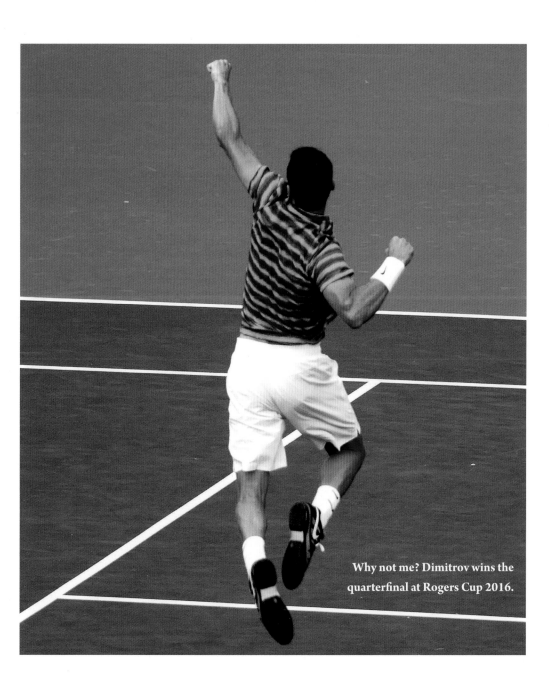

Why not me? Dimitrov wins the quarterfinal at Rogers Cup 2016.

Dimitrov has a temper. He's described, politely, as fiery. In Helsinki in 2010 he attacked an umpire. In 2016 in his Istanbul final against Diego Schwartzman he forfeited the match after smashing three rackets in one set and ending the match prematurely in a fit of rage. These days he breaks about twenty rackets a year, which he says is less than before.

"You're human, you're playing tennis, so why not you one day?" says Dimitrov. "This is the one thing I was saying to myself quite a lot lately: Why not me?" It's a big question. The answer to it is uncertain.

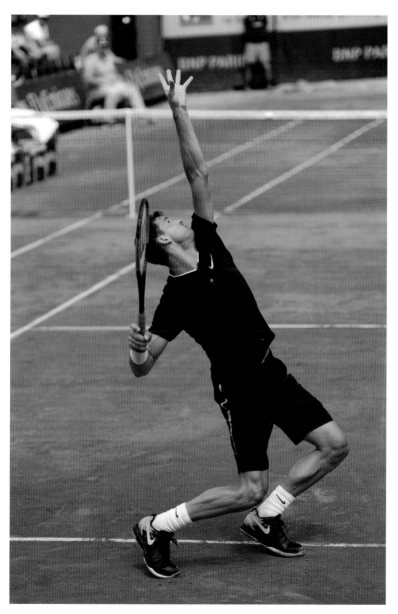

A beautiful serve . . .

Milos Raonic

"You have a great future."—Andy Roddick to Milos Raonic

When Milos Raonic was twelve years old, his coach Casey Curtis pointed him out to one of the new staff on his team and said, "This is the future number one in Canada." Then he added, "and a future Top 100 in the world." About ten years later, Casey revised his opinion. He said: "I actually believe he can be number one in the world and win a Grand Slam tournament."

As of early 2018, it hasn't happened, and time is running out.

Milos Raonic was born in Podgorica, Montenegro, in 1990 and moved to Canada with his family when he was three. The family settled in Brampton, near Toronto, and after a few years moved to the Toronto suburb of Thornhill. Both his parents are professional engineers. No one in the family had ever played tennis.

Raonic is six-foot-five and weighs over two hundred pounds. His size has helped him develop an extremely fast serve, his best shot; he has recorded the sixth fastest serve in tennis history, at 155 mph. In 2012, TV analyst and former tour player Patrick McEnroe said, "The Canadian youngster Milos Raonic—they call him the 'Missile'—has probably got one of the biggest serves in the game."

When Raonic was six, his parents were looking for something for him to do during his school's March break. A local tennis club was running a weeklong camp. Milos took group lessons, followed later by once-a-week tennis classes. When he was eight he asked his father, Dušan, if he could take up a racket sport. Blackmore Tennis Club in Richmond Hill was close by, and the renowned junior coach Casey Curtis was running a program there. Curtis suggested practice with a ball machine until Milos was good enough to join the program. Every day before school, at 6:30 in the morning, the young Milos would practice, then go to school, and then practice more in the evening. After two months he was good enough to join Casey Curtis.

Raonic competed as an amateur in junior International Tennis Federation events. The plan was to get a university tennis team scholarship in the United States and study

With Casey Curtis, 2013.

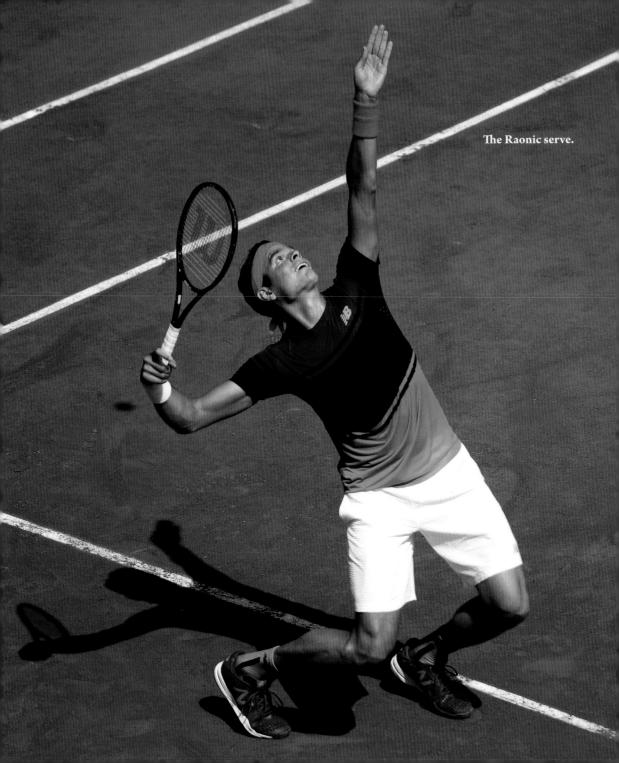

The Raonic serve.

finance to prepare for a non-tennis career. In the summer of 2008, ranked No. 937 in the world, Raonic decided to postpone university and try a professional career. His parents agreed, provided that he broke into the Top 100 within two years.

In 2011, Raonic qualified for the Australian Open, where he had his breakthrough performance, advancing to the fourth round (he lost to David Ferrer). By the end of February, Raonic was No. 37 in the world, the highest ranking ever achieved by a Canadian. He received rave reviews for his Australian Open performance. Patrick McEnroe said, "Raonic is the real deal." BBC Sport referred to Raonic as part of "a new generation." Martina Navratilova said Raonic was "a new star," adding "the sky is the limit." *The Sydney Morning Herald* described Raonic as a "future superstar." Two weeks later, he won

Davis Cup 2010, just before the 2011 Australian Open breakthrough.

his first ATP title at the Pacific Coast Championships in San Jose, California. A week after that, Raonic reached the final of an ATP 500 tournament for the first time at the U.S. National Indoor Tennis Championships. He lost in three sets to No. 8 Andy Roddick, with Roddick making a diving forehand to break serve for the match on his fifth championship point. Roddick stated: "That's the best shot I've ever hit in my life, considering the circumstance." At the trophy presentation Roddick said, "You have a

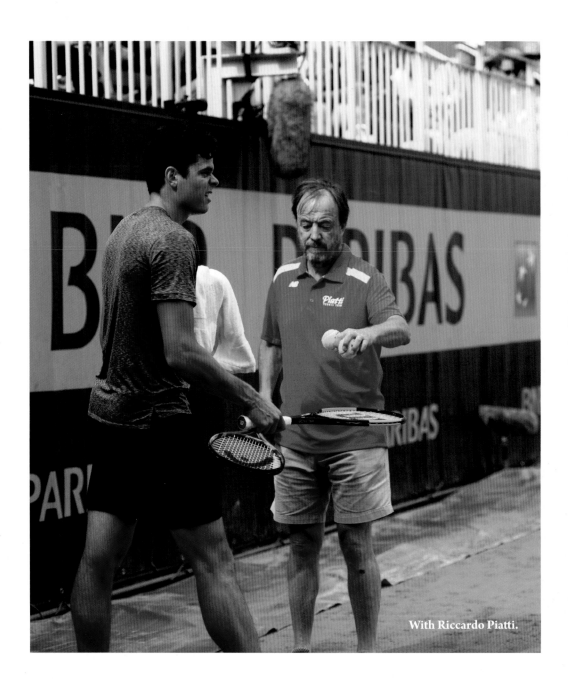

With Riccardo Piatti.

Looking to the future.

great future ahead of you. And I know what I am talking about. I've seen many up and coming players throughout my career."

Raonic is known for his drive and work ethic. He is a serious man. In 2010, he hired Galo Blanco as his coach and moved to Spain to train. Blanco was later replaced by Ivan Ljubičić (who left to work with Roger Federer), followed by Carlos Moyá (working now with Rafael Nadal), Riccardo Piatti (former coach of Novak Djokovic), and John McEnroe. And there was a short stint with former Wimbledon Champion Richard Krajicek, as well as doubles specialist Mark Knowles.

By November 2016, Raonic was No. 3 on the ATP Tour. That year he played his first Grand Slam final (Wimbledon, where he was beaten by Andy Murray). But his goal and dream to be world No. 1, and to win major titles, still escapes him. His 2017 season was plagued with injuries—to the hip, wrist, and calf—and he skipped the US Open. Though he came back for the Rakuten Open in Japan, Raonic retired after winning in the first round and playing only one game in the second round. At the end of 2017, for the first time since August 2012, Raonic was out of the Top 20 (number 24). He was without a coach, with few high-caliber choices available.

He says he will be back. To do it, he has to be healthy and put together a new coaching team. Will he have enough time? Will he be able to fight off the surge of new players? The mountain is getting steeper for Milos Roanic.

Jack Sock

"Obviously Nebraska is the best place for tennis players."—Jack Sock

It's tough to be an American tennis player, following in the footsteps of Connors, McEnroe, Sampras, Agassi, and Courier. Expectations are, to say the least, high. Jack Sock, currently ranked No. 8 on the ATP tour, knows this well. "The goal for the top American isn't the top twenty—it's top ten, top five, number one in the world," he said in a 2017 *Esquire* article entitled, "Is Jack Sock the Future of American Tennis?"

Jack Sock was born in 1992 in Lincoln, Nebraska (the same state where the last American No. 1-ranked ATP player, Andy Roddick, came from). He took up tennis at the age of eight, when he found an old racket that belonged to his mother. When Sock was ten years old his mother would drive him and his brother Eric to Overland Park, Kansas, for weekend tennis lessons.

Sock's success started at a young age. In high school in Kansas he had an 80–0 record and won four consecutive state championships. In 2010, he won the US Open Junior title before turning professional in 2011. Initially, Sock didn't get much recognition or respect. "No offence, but who is Jack Sock? A kid from Nebraska who is 19 years old with 332 ATP singles rating," wrote renowned Canadian coach Pierre Lamarche on ONtennis.ca in 2011. With fellow American Melanie Oudin, he won the 2011 US Open mixed-doubles title. In June 2013 he finally broke into the Top 100. People started to pay attention.

With a very strong serve (recorded at 141 mph), Sock has often been compared to Andy Roddick, though he sees his style closer to that of Rafael Nadal. In an interview during the 2012 Memphis Open, Sock said, "Nadal prefers the forehand to the backhand and hits with incredible spin. I also like to hit with more spin than pace and prefer my forehand." Christopher Clarey of the *New York Times* described the Sock forehand as "one of the most remarkable shots in the game: a wicked, whipping stroke hit with such an extreme western grip that it just might be creeping full-circle toward eastern."

Roland Garros 2015.

The Sock serve.

Sock's success at 2014 Wimbledon was almost accidental. At the last minute he found that Canadian Vasek Pospisil was available for doubles. This was their first tournament playing together, yet they advanced to the finals and won the title, beating doubles legends the Bryan Brothers in five sets. Sock and Pospisil continued playing together in 2015. They won Indian Wells and were finalists in both Miami and Paris. In 2016, they were the finalists in Indian Wells and Rome. Sock also won a silver medal in mixed doubles at the 2016 Rio Olympics, playing with Bethanie Mattek-Sands.

He's a sentimental family guy. In 2015, just before Roland Garros, he tweeted "you'll be with me on the court here in Paris grandpa. stay strong in your battle with Alzheimer's. I love you" and wore the slogan "#4Ugpa" on his shoes. In January of 2015 his brother Eric was diagnosed with Lemierre's Syndrome, a rare bacterial infection that can be fatal and was attacking his liver, kidney, and heart. Jack inscribed "4UERIC" on his tennis shoes and cried on the court and in interviews at Indian Wells in March.

Sock won three titles in 2017. During the last Masters 1000 level tournament of the year (Paris), in his first round, Sock was down 5–1 in the third set to Kyle Edmunds from England (he lost the first set 4–6 and won the second 7–6). Somehow he managed to win the match in a tiebreaker. He went onto win four more matches for his first Masters 1000 title. Sock advanced to No. 9 on the ATP tour, and with that win, qualified for the end of season ATP Finals in London (the first American to do so since Mardy Fish in 2011).

In London, Sock advanced to the semifinals, but lost to Grigor Dimitrov, who went on to win in the final. Along the way, Sock beat World No. 3 Sascha Zverev. When asked about his success, Sock said in an interview for worldtennisusa.org: "We kind of said, 'Screw it, take that pressure off yourself; go have fun on court again.' I enjoyed being on the court. With the pressure I was putting on myself, I wasn't having the fun times that I had at the beginning of the year and in the past." And, based on the fact that Andy Roddick was the last American player to reach the semifinals in London (2007), Sock added, "Obviously Nebraska is the best place for tennis players."

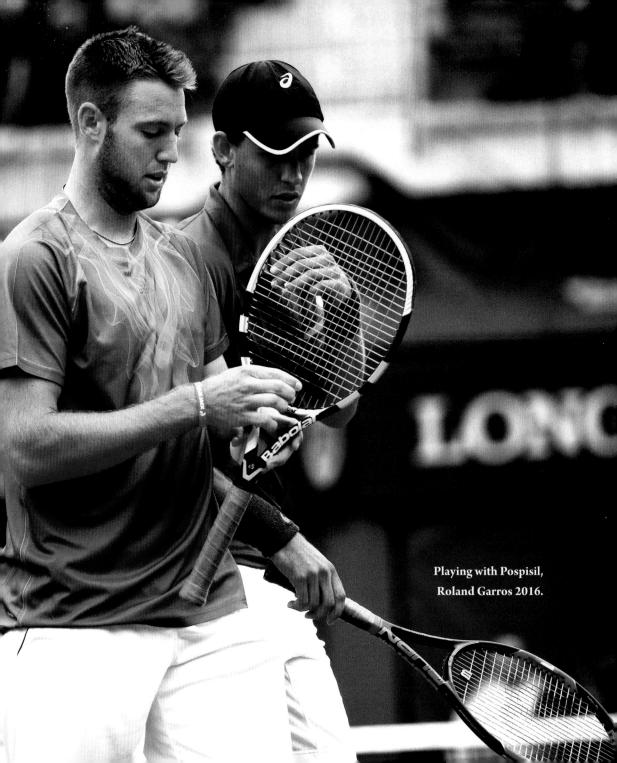

Playing with Pospisil,
Roland Garros 2016.

Sock shoes.

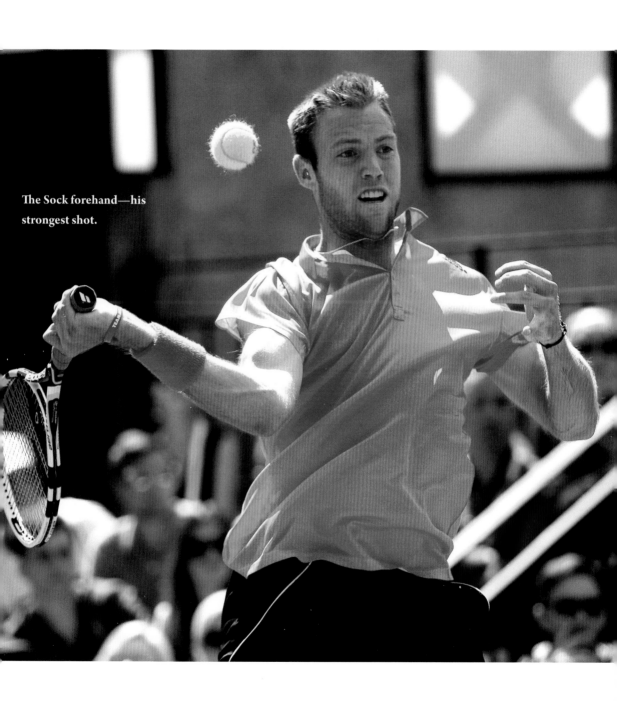

The Sock forehand—his
strongest shot.

Kevin Anderson

"I feel I'm getting better at it."—Kevin Anderson

It took South African Kevin Anderson 35 tries to make it to a Grand Slam final. It happened at the 2017 US Open. He lost to Rafael Nadal (6–3, 6–3, 6–4), but for the thirty-one-year-old Anderson in his 10th year on the tour this was a record-breaking performance. Anderson was the first South African man since Cliff Drysdale in 1965 to make the finals in New York. He was also the lowest-ranked player to play on the last day of the tournament since the ATP ranking was established in 1973. And, at six-foot-eight, he was the tallest.

Johan Kriek, former Top 10 player and two-time Australian Open champion (1981 and 1982) thinks the success of tennis in South Africa is partly due to that country's good weather. "For a small country like South Africa we've had enormous success in tennis. The weather is good all year long, similar to Southern California. Tennis is a vibrant sport here. But sadly, most talented kids need to leave South Africa to gain experience in Europe and in America."

Anderson accepted a tennis scholarship at the University of Illinois before turning professional in 2007. He excelled during his three-year career in college tennis. He was a three-time All-American in singles,

Anderson is known for one of the strongest serves on the ATP Tour (Roland Garros, 2013).

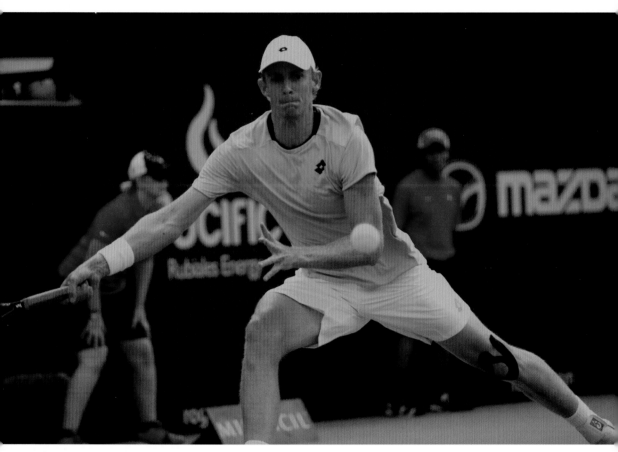

Quarterfinals at the Rogers Cup in Toronto, 2014.

and two-time All-American in doubles, leading his team to the finals in 2007. At college he also met his future wife—golfer Kelsey O'Neal (they married in 2011).

Anderson became the first player with college ties to reach a Grand Slam singles final since Todd Martin at the 1999 US Open. "I really didn't know too much about college tennis when I was in South Africa," Anderson said in an interview with ESPN. com. "My last year of juniors I started getting calls from coaches, and the more we looked at it, the more we realized it was a very worthwhile opportunity to explore."

After breaking into the Top 100 in the ATP rankings (April 19, 2010), Anderson recorded a steady climb that saw him reach the Top 20 in 2013 (October 7) and—for one glorious week—the Top 10 (October 12, 2015).

But being a Top-20 player did not translate into winning tournaments. Anderson won his maiden title in 2011 (South Africa), and another one in 2012 (Delray Beach). For the third, he had to wait three long years before winning the 2015 Winston-Salem Open. As Kriek explained: "Kevin is an incredibly hard-working professional. But winning a tournament on the ATP tour these days is a daunting task. And because of his ranking Kevin has to play all the top tournaments [1000 level]—and those are not easy to win." There is also his reliance on his serve. "He has a huge serve and plays the big manpower game as those tall guys do," says Kriek, "and sometimes when the serve is off, it affects the entire game." His style is also generally somewhat different from that of most players. Historically, he has been quiet on the court. Even the inscrutable Roger Federer has often looked more intense than Anderson.

But the 2017 US Open saw a different Kevin Anderson. He was energetic, rushing to his chair on almost every changeover, doing a lot of fist pumping. He was asked about the change in his style during a press conference at the US Open: "I don't know. . . . You know, I feel like it allows me to play better tennis. That's something I have always been looking, you know, at any edge I can get."

Johan Kriek likes what he sees. "With that fist pumping, he is staying positive more, and I think it has helped to keep the 'doubts' away."

Anderson's new coach, Brad Stain, is credited for the change in Anderson's style and approach to matches. When they started working together in 2017, they agreed that it was time for Kevin to start winning tournaments. Talking about his new

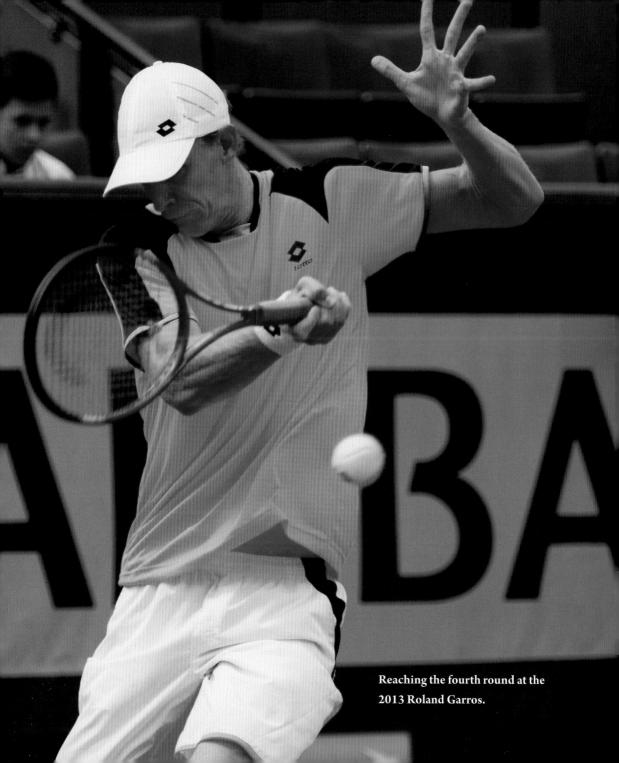

Reaching the fourth round at the
2013 Roland Garros.

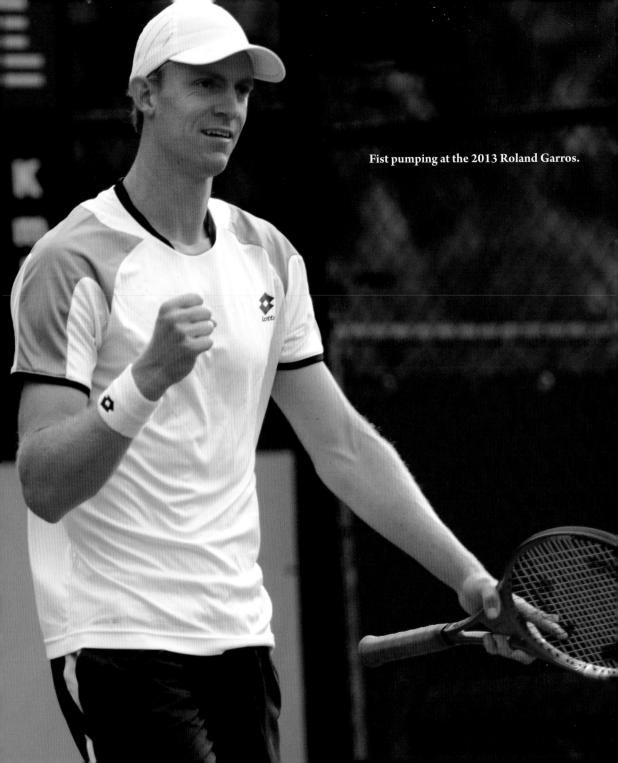
Fist pumping at the 2013 Roland Garros.

approach to the game in an interview with tennis.com, Anderson explained: "I really try to target every tournament I play. Obviously we are looking at the Grand Slams and wanting to do well there, but definitely one of my goals is doing well in the Masters 1000s, because I haven't progressed beyond the finals and quarterfinals. I want to make some semis and finals and hopefully win some." Anderson has noted that he'd like to play more like Nadal in terms of bringing his highest level of intensity to each match. "If you can be fully aware of bringing your best to each and every point, you are going to be a more dangerous player. Nadal does an amazing job with that. He plays every point like a match point." So far the plan is working. Anderson chalked up his fourth title (February 2018) in New York at the New York Open. "My best game is just as good as [Roger] Federer's or [Rafael] Nadal's, they just can play it more often than I do, but I feel I'm getting better at it," he said during the 2018 Indian Wells tournament in an interview with tennisworldusa.org.

BRASH

Fabio Fognini

"I'm only human."—Fabio Fognini

Fabio Fognini swears a lot when he plays tennis. He abuses the ball and the chair umpire. He shouts insults at spectators. He smashes his racket. He's been called "Harakiri Fognini" and "Fogna" (Italian for "sewer"). He's very emotional. He easily gets very angry. But he plays a good game of tennis. At the end of 2017 he was ranked No. 27 in the world. He has been as high as No. 13 (in 2014). He's No. 1 in Italy.

Take the 2017 Wimbledon, where in the third round Fognini seriously threatened Andy Murray with defeat. In a thrilling game, Murray eventually narrowly won in four sets in what was described as a "desperate" victory. Kevin Mitchell, writing in the *Guardian*, said, "Fognini . . . now induced shivers of uncertainty in Murray's stroke-play, freezing his self-confidence as he barrelled into every exchange as if it were the last rally and he was about to win the title. . . . There is a widely held and correct view on the Tour that to strike Fognini on one of his great days is very hell." Fognini had easily beaten Murray earlier in the year, in two sets, at the Internazionali BNL d'Italia in Rome.

Fognini might have won against Murray at Wimbledon 2017 if he had not been handed a penalty point for an obscene gesture, putting his finger into his mouth and sucking it. This was not the first time Fognini had gotten into trouble at Wimbledon. In 2014 he had to pay the largest fine in Wimbledon history for an outburst on court when he damaged the grass surface with his racket, verbally abused a tournament official, and, again, made an obscene gesture to his opponent. Obscene gestures and comments are routine for Fognini. At the 2014 Shanghai Masters, he gave the crowd a middle finger. In 2013, in Hamburg, he called his winning opponent, Filip Krajinović, *"zingaro di merda"* ("shitty Gypsy").

Fognini was born in 1987 in San Remo, Italy. He began playing tennis when he was four years old (although he's said that his favorite sport is soccer). He is a clay-court

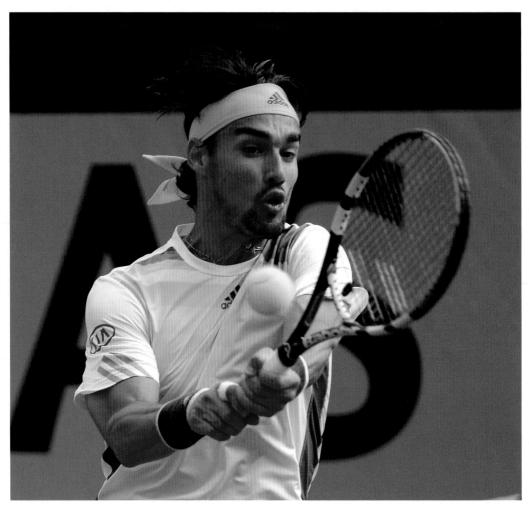

He can play a good game of tennis.

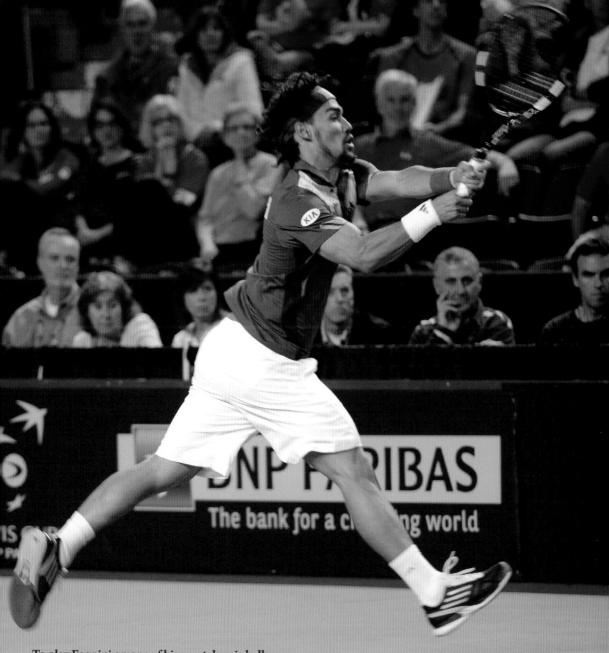

To play Fognini on one of his great days is hell.

specialist who attracted serious attention when he reached the quarterfinals at the 2011 French Open. His hot temper has consistently hampered him.

In June 2016 he married Flavia Pennetta, another Italian tennis star, who earlier had had a disastrous and very public love affair with Carlos Moyá, former world No. 1. In 2015, Pennetta won the US Open and then retired. One newspaper reported: "Beaming down from the stands in celebration of her triumph on Saturday was the Italian tennis radical, Fabio Fognini. He had put Nadal out of the men's draw in the third round, returned to Italy to wind down and rushed back to New York when Pennetta made the final." In May 2017, the couple had a son, Federico. At the July 5, 2017, Wimbledon press conference, Fognini was asked, "How is fatherhood? Do you think it has an effect on your tennis?" He replied: "Well, I don't know. You have to say. I mean, at the moment I'm really happy, happy because my family is well, they're rightly. Baby is good. I'm good, too. I'm feeling really good. Nothing else to say. We are really happy, enjoy when I went home these three weeks before coming here." Tennis wags hoped that marriage to Pennetta would calm Fognini down. It didn't.

"*Troia!*" "*Bocchinara!*" ("Whore!" "Cocksucker!") That's what Fognini called the female chair umpire, the Swede Louise Engzell, at the first round of the 2017 US Open (he lost the match). Fognini later apologized for his behavior and explained that everyone has bad days. "I'm only human," he said. An outraged Rafael Nadal said that the International Tennis Federation was too slow in responding to Fognini's obscene tirade. Fognini, bizarrely, said he was prepared to discuss his mistake with schoolchildren. "I'm prepared to enter a tennis school, or any school, and speak to the kids and say what I think—which is that I made a mistake and it won't happen again." He told a reporter, "I am working with a mental trainer. . . . cried when I was alone, I admit it." In October 2017 the Grand Slam Board banned Fognini from the US Open and one other grand slam, a ban to take effect if he committed another major offense before the end of 2019. It also fined him $96,000, reduced to $48,000 if he stays on good behavior for the next two years (in addition to the

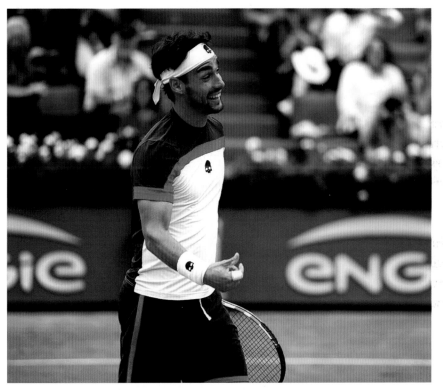

At Roland Garros 2017 Fognini lost in straight sets to Wawrinka, but seemed happy.

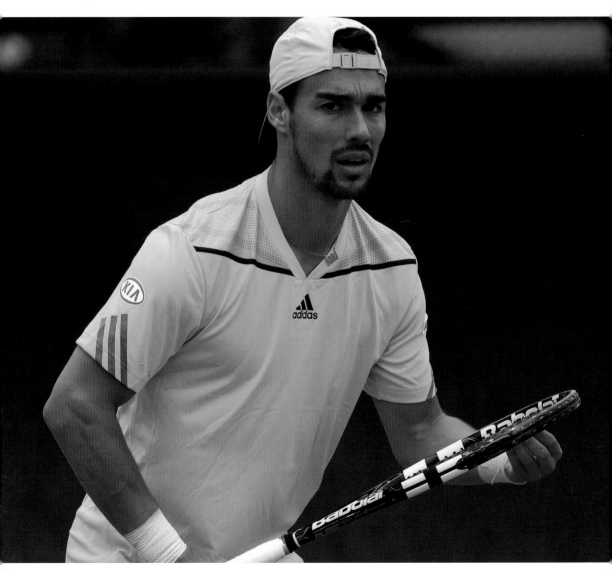

His own worst enemy?

$24,000 he already paid on-site at the time he insulted Engzell). This punishment was criticized by many as inadequate and taking too long to impose. One commentator asked, "Well-intentioned as the board's decision in the Fognini case may be, it still leaves a question hanging: What does a guy have to do to get suspended around here?"

Ernests Gulbis

"I have a helicopter, a submarine, and a spaceship."—Ernests Gulbis

At Wimbledon 2017, to everyone's great astonishment, Ernests Gulbis, ranked No. 589 in the world, easily beat the great Juan Martín del Potro, ranked No. 32, winner of the US Open in 2009, in straight sets, in the second round. Gulbis served twenty-five aces. He stymied del Potro's powerful forehand with his trademark drop shots and lobs. Said del Potro afterward, "If Ernests has a good day, he can beat all the guys on tour." The next match for Gulbis was with Djokovic. An easy win? Not for Gulbis. Djokovic took it in straight sets.

Ernests Gulbis, born in 1988 in Latvia and named after Ernest Hemingway, does not need to play tennis to make money (although he has earned more than $6 million so far). His father, Ainārs, one of Latvia's richest men, is an investment banker with a private jet that, rumor has it, he makes available to Ernests. His mother is a well-known theater actress (his parents are divorced, and he was raised by his mother). His mother tried to convince Ernie, as he is called on the tour, to quit professional tennis. "But it is nice to have your own money, to make your own mark on things," he said. When asked by a journalist if he traveled by private jet, Gulbis answered, "Yes. And I have a helicopter, a submarine, and a spaceship."

Gulbis is often described as an international playboy. Early in his career he was a famous partygoer. "I've done all the possible wrong things that you can do in a tennis career," Gulbis told an interviewer. "The mistakes are simple. After playing a good tournament, you get a week off. You can spend that week the right way, going for a one-hour run each day or going to the gym. Or you can do nothing like I did. You eat and drink whatever you want and not sleep at night."

In 2013 the *New York Times* described him as "one of the game's best talkers, unabashed partiers and biggest personalities." Gulbis gave the *Times* a frank interview. "I truly believe that I am better than some of the guys who are winning, and who are higher ranked. . . . My goal is not to be ranked No. 50 in the world, from No. 50 to

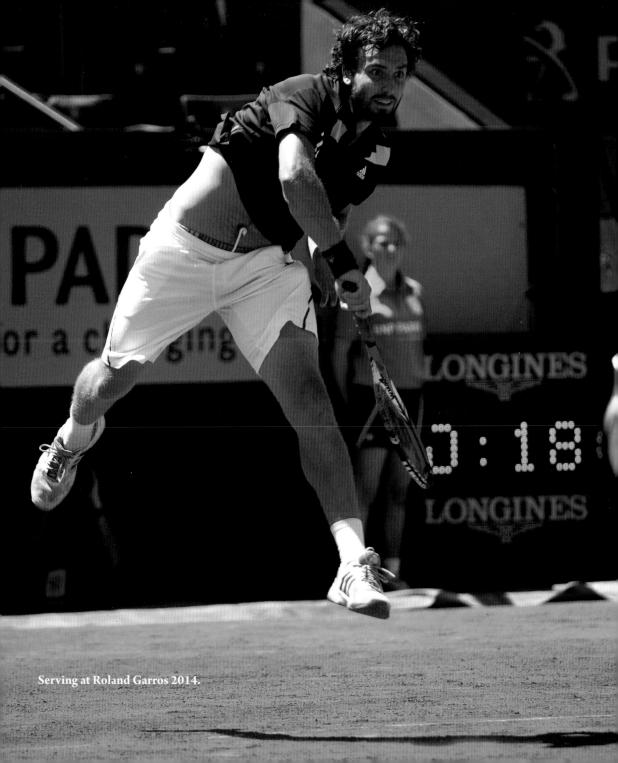

Serving at Roland Garros 2014.

100 all my career. For what? It doesn't interest me. So I'm going to try to do it maybe, I don't know, four, five more years, that's it. And then I have no regrets when I'm done." He told another interviewer, "I was really getting pissed to see who's in the Top 100. There are some guys who I don't know who they are. Some guys, I'm sorry—with respect—they can't play tennis. I don't know how they got into the Top 100. I think I'm much better than them."

Gulbis gets into trouble. In 2009, he was arrested in Stockholm for soliciting a prostitute (he claimed it was a misunderstanding). He commented later, "I'm never going to go to Sweden again. If you go out and meet some girls, and immediately you're put in jail, that's not normal." He has criticized the Big Four in an intemperate way. In 2013, he told *L'Équipe* magazine: "I respect Roger, Rafa, Novak, and Murray but, for me, all four of them are boring players. Their interviews are boring. Honestly, they are crap." He told the *Guardian* newspaper: "I would like interviews to be more like in boxing. OK, maybe those guys are not the most brilliant on earth but, when they face each other down at the weigh-in, they bring what the fans want: war, blood, emotion. All that is missing in tennis, where everything is clean and white with polite handshakes and some nice shots, while the people want to see broken rackets and hear outbursts on the court." When asked about the possibility of his three sisters playing tennis, he said that women should focus on family and kids and not bother with tennis. Maria Sharapova commented: "I don't think we can take everything serious when he speaks."

Gulbis is said to smash seventy rackets a year. "I went to the factory where they make the rackets and I saw all the work they do. Everything is hand-made. They do everything for the players; they really think about what the players need, and then an idiot like me comes and breaks them. On the hard court, where it's more difficult to break a racket, with one try I broke a racket in five places. I am emotional. Though I don't do it because something bugs me. It's just a stupid habit." Later he told a somewhat different story. "I realized that it's not wrong at all because it's work for them and the rackets aren't expensive to make. It's more publicity for the manufacturers as well. All the cameras are on the racket when you smash it."

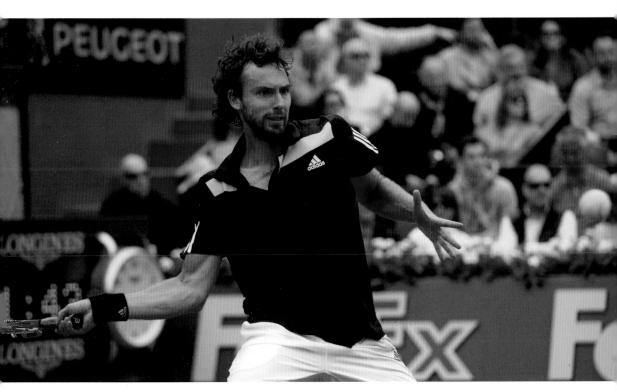

The Gulbis forehand.

"I truly believe that I am better than some of the guys who are winning." Djokovic beat Gulbis in the 2014 Roland Garros semifinal.

On the last-chance train, working with his
coach Larry Stefanki 2016.

In 2014, he got to the semifinals at Roland Garros, where he lost to Novak Djokovic, though he had beat Roger Federer along the way. Gulbis said he celebrated his semifinal run by blowing his winnings—more than $500,000—at a Latvian casino. After his 2014 breakthrough, when he was ranked world No. 10, Gulbis struggled for most of 2015, sinking to the bottom of the top 100, and then plummeting in 2016 and 2017. He said he was on "the last-chance train."

"Grand Slam is Grand Slam," he said in 2014. "You don't need easy way to win it. If you can't make it, you can't make it. Sorry. Stay at home and do something else. Grand Slam should be five sets, blood, fight five sets all the way until the end, until somebody is dead."

As of November 2017, Gulbis, still alive but on the last-chance train, was ranked No. 199.

Nick Kyrgios

"I didn't ask you to come watch."—Nick Kyrgios

Nick Kyrgios's breakthrough match was the fourth round of Wimbledon 2014. He was playing Rafael Nadal, his boyhood hero, then world No. 1. Kyrgios, a nineteen-year-old wild-card entry ranked No. 144, beat Nadal in four dramatic sets, 7–6, 5–7, 7–6, 6–3.

Kevin Mitchell in the *Guardian* newspaper called the Kyrgios/Nadal match "an upset for the ages" and described Kyrgios as "an Australian teenager with no fear and a golden arm." Mitchell wrote: "Kyrgios's nerveless performance, built on a serve to inspire fear and admiration, embroidered the occasion so completely with his free spirit and irresistible power. . . . What a game. What a day. What a player."

Playing the great Nadal at Wimbledon, Kyrgios exuded brilliance and confidence. And he was so young. It was his serve, including his powerful second serve, almost as fast as his first and getting faster all the time, that gave him the edge. Match point was an ace, one of thirty-seven Kyrgios aces that day. At the end of it, Kyrgios did a little dance, something he later called "a juicy wriggle." He didn't seem surprised that he had beaten Nadal.

Brilliant, maybe, but Nick Kyrgios is a bad boy. He's been called immature, temperamental, petulant, lazy, rude, mentally erratic, tempestuous, unconventional, the most misunderstood man in tennis, pugnacious, a "moochy" rebellious man-boy, brittle above the shoulders, a wild child, and a pantomime villain. He often says he is in "a pretty dark place." At Roland Garros 2017, he told reporters, "I tend to be very negative and I have lots of chats to myself, and it's not really positive chat." He swears at fans in the crowd who annoy him. "Put your fucking phone away!" is one of the things he yells. Sometimes he prefers to play Pokémon GO with teenage friends rather than train for an upcoming match. His fitness has become an issue. He has said, "I don't really like running. When the rally gets pretty long, I tend to just go for a low-percentage shot." An Australian newspaper column about Kyrgios had the

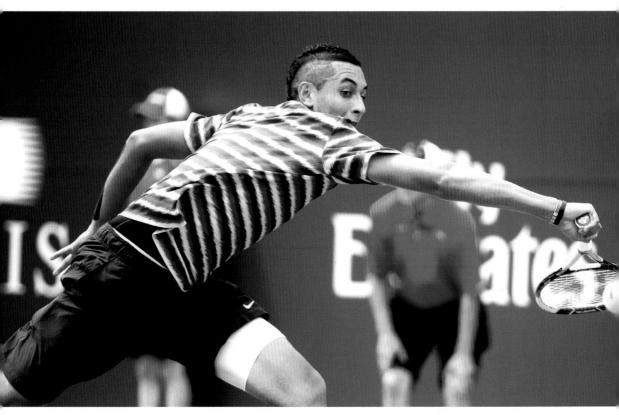

Pundits say Kyrgios can be No. 1, partly because of his supreme athleticism.

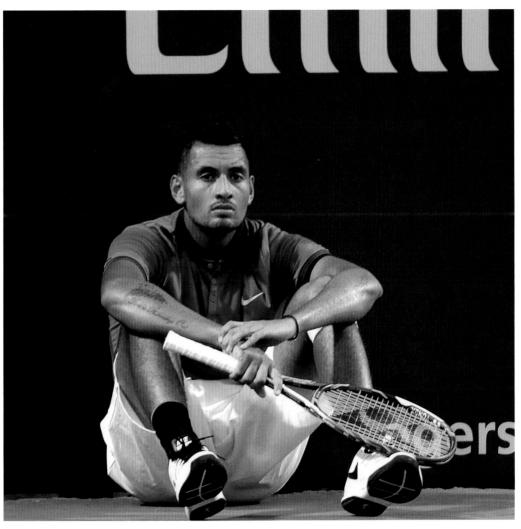

Kyrgios lost to Shapovalov in the first round of Rogers Cup 2016.

headline "Nick Kyrgios is a National Embarrassment." When Ken Rosewall said the image of Australian tennis was being tarnished by members of the current generation, Kyrgios tweeted, "Same shit everyday man. people need to stay in their lane." But Rod Laver is a fan, albeit his praise is qualified. Says Laver: "Nick has got more talent than anybody on the tour, but sometimes his attitude just does damage to his life as a player."

Bad boy, yes, but Kyrgios is also funny, charming, a superb shot-maker, a maturing titan, the future of tennis, and—perhaps most important of all—bankable. In January 2017, after he lost in the second round of the Australian Open to Andreas Seppi (Kyrgios was booed off the court at the end of the game), the *New York Times* described him as "maddening and fascinating" and a "tortured genius." Paul Annacone, a former coach of both Roger Federer and Pete Sampras, described him in 2017 as the greatest player since Federer. John McEnroe is often critical of Kyrgios's tantrums (he has called Kyrgios a "fellow head case"), but has said that he is the most gifted player of his generation. At Roland Garros 2017 (where Kyrgios was beaten in the second round by the South African Kevin Anderson), McEnroe said, "It is unbelievable how talented Nick Kyrgios is. He is the most talented young player in the world." He beat Federer (Madrid 2015), Rafael Nadal (Wimbledon 2015), and Novak Djokovic (Indian Wells 2017) at their first meeting. "You give that guy an early break, man, you're goodnight Irene," analyst Brad Gilbert said after the Djokovic defeat at Indian Wells.

He was tipped by many to do very well at Wimbledon 2017, perhaps even win. He resigned in the first round, after dropping two sets to Pierre-Hugues Herbert, hobbled by a left hip injury. The *Guardian* reported, "Kyrgios shrugged his shoulders, fiddled with the skin on his fingers and buried his face in his towel. . . . More than anything, there was an unmistakable sadness to his demeanour." The next day, the tabloid press delighted in reporting that after his defeat Kyrgios had partied with two teenage women at a London nightclub. Then, he bought a 700-horsepower $180,000 Dodge Challenger Hellcat. In October 2017, at the Shanghai Masters, he walked off the court after losing the first set of the first round. He was fined and stripped of his first-round prize money. Later, Kyrgios said he'd had a stomach bug.

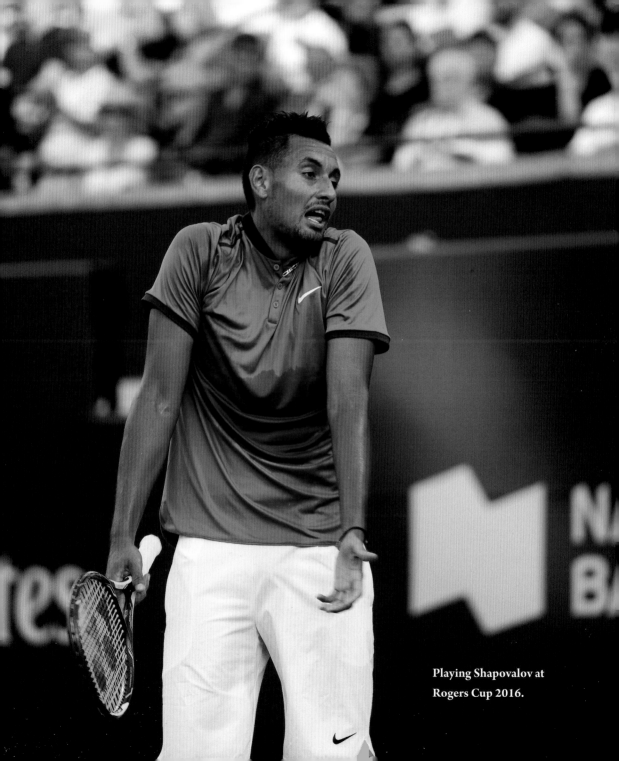

Playing Shapovalov at
Rogers Cup 2016.

He can be uniquely horrible. At the 2015 Montreal Masters, his lewd comments on the court to Stan Wawrinka about the sex life of Wawrinka's girlfriend earned him the adjective "loathsome" and the description "one of the most hated sportsmen in the world" in the *Telegraph* newspaper, and led to a postgame locker-room bust-up between the two players. In 2016 the ATP suspended him for lack of effort at the Shanghai Masters, what it described as "conduct contrary to the integrity of the game." Simon Briggs, tennis correspondent of the *Telegraph,* wrote, "Nick Kyrgios's commitment levels have always tended to wax and wane in accordance with some mysterious music of the spheres. But he has never reached quite such a nadir of indifference as he did in Shanghai today, while blatantly throwing a match against Mischa Zverev." When asked at the postgame press conference how he felt about being booed by the fans, Kyrgios said, "I don't owe them anything. It's my choice. If you don't like it, I didn't ask you to come watch." When he played Kevin Anderson in the second round of Roland Garros 2017, he asked fans mid-match for a beer ("Get me a beer now. Honest to God, get me one now."), and when he lost smashed his racket to smithereens in front of some bewildered children. At the French Open, Kyrgios said he doesn't like to practice on red clay back at home in Canberra because "it gets my car dirty."

But Kyrgios can also be brilliantly charming. Here's the Australian Broadcasting Corporation reporting on Kyrgios at the 2017 Cincinnati Masters, where he beat Nadal and lost in the finals to Dimitrov: "Kyrgios played twinkling tennis. When at his best he solicits more 'oohs' and 'aahs' from tennis crowds than anyone on the circuit, barring perhaps Roger Federer. He had Cincinnati in the palm of his hand. . . . Throughout the tournament, aside from being brilliant, Kyrgios was well-behaved and gracious. He had kind words for Dimitrov and charmed the crowd by praising their city and inviting them all out to ice cream next time he's in town."

He's an Australian, born in 1995. His father, Giorgos, who has a house painting business, is from Greece. His mother, Norlaila, a software writer, was born in Malaysia of royal blood (early on she abandoned the title "princess"). He was devoted to his grandmother, Julianah Foster, and has a tattoo of the number "74," Julianah's age when she died. Kyrgios was fat as a child ("I ate a lot"), but despite his weight was an excellent athlete, particularly interested in basketball. He's called himself an "accidental

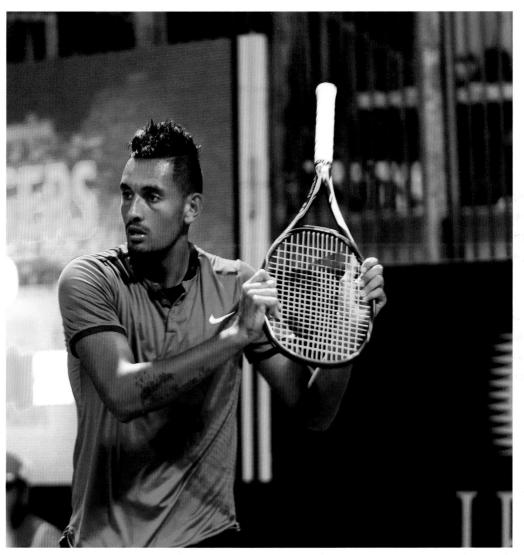

**A petulant Kyrgios playing doubles with Sock against
Pospisil and Nestor, Rogers Cup 2016.**

tennis player" and has said that "some days it's fun to play but sometimes I'd rather be doing something else."

According to Kyrgios, one day he will leave tennis and become a professional basketball player. At the 2017 French Open, Kyrgios divided his time between playing tennis and watching the NBA Finals. He announced he wouldn't miss a moment of the NBA Finals, French Open or no French Open. In a radio interview, he said, "I feel like I could have eight assists playing for the Golden State Warriors. There's so many guys to pass to. Definitely, I would average some pretty good numbers if I played for them as well."

In 2017 Kyrgios announced he had found his purpose. "A couple of years ago I had a vision: to build a facility for disadvantaged and underprivileged kids where they could hang out, be safe and feel like they were part of a family. There'd be tennis courts and basketball courts and a gym and an oval to kick the footy. There'd be things to eat and beds to sleep in. . . . For the first time, I feel like there is a reason for me to be doing what I'm doing. Tennis is a great life—we're well paid and the perks are pretty good—but it can feel empty if you're just doing it for the money."

When will he leave tennis? Will the injuries that plague him overwhelm his motivation, as happened at 2017 Wimbledon? What will he be when he leaves the game? World No. 1, a titan of tennis? Or a reviled oddity?

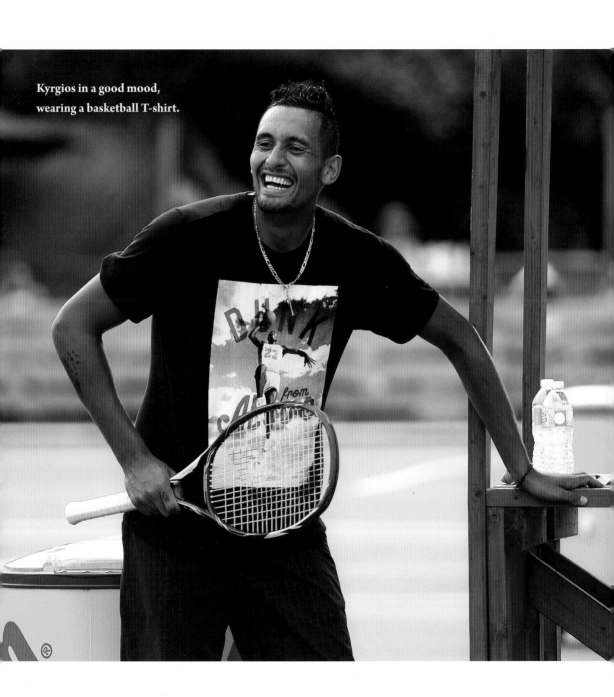

Kyrgios in a good mood,
wearing a basketball T-shirt.

Bernard Tomic

"You probably don't like me."—Bernard Tomic

It's a sad story, one of much promise and much anguish. How will the sad story end? Bernard Tomic was—perhaps could still be—one of Australia's great tennis stars. But Tomic has been undermined by his inability to deal with the pressures of being in the spotlight, with the relentless demands of the ATP tour, and by his immaturity. At the end of 2017 Tennis Australia chief Craig Tiley expressed concerns about Tomic's mental well-being and offered him something called "well-being support."

In early 2016, Bernard Tomic was ranked 17 in the world. At the end of 2017, he was ranked No. 142. His slide has seemed inexorable, and has accelerated. He has seemed more interested in a celebrity life than hard work. It's not a new story for Tomic. Tennis Australia cut his funding in 2007 while he was still a junior because of his lack of effort at the 2007 French Open juniors. In 2009 he was fined by the International Tennis Federation for walking off the court during a match in Perth (directed to do so by his father, who objected to the officiating). That same year he rejected an invitational practice from his countryman and former world No. 1 Lleyton Hewitt because Hewitt was "not good enough." In 2012 Tomic had several run-ins with the police, including three fines for traffic violations on the same day: later, he lost his driving license entirely after being caught speeding in a yellow Ferrari. In 2015, Tomic was arrested in Miami on charges of trespassing and resisting arrest after a late-night party in a $10,000-a-night hotel penthouse (the charges were later dropped). He has gained a reputation for deliberately losing matches, and has sometimes been called "Tomic the Tank Engine." His hotheaded father (criminally convicted in Spain in 2013 for assaulting Bernard's hitting partner, Thomas Drouet) has threatened that Bernard will quit Australia and play for Croatia.

Despite his talent for self-destruction, some tennis observers have seen great promise in Tomic. In January 2012, when Tomic was already tagged by many as lazy and petulant, Geoff Macdonald, reporting for the *New York Times* on the Australian Open,

When Tomic came on the scene, his potential seemed unlimited.

Tomic with his father, John, at Roland Garros 2015.

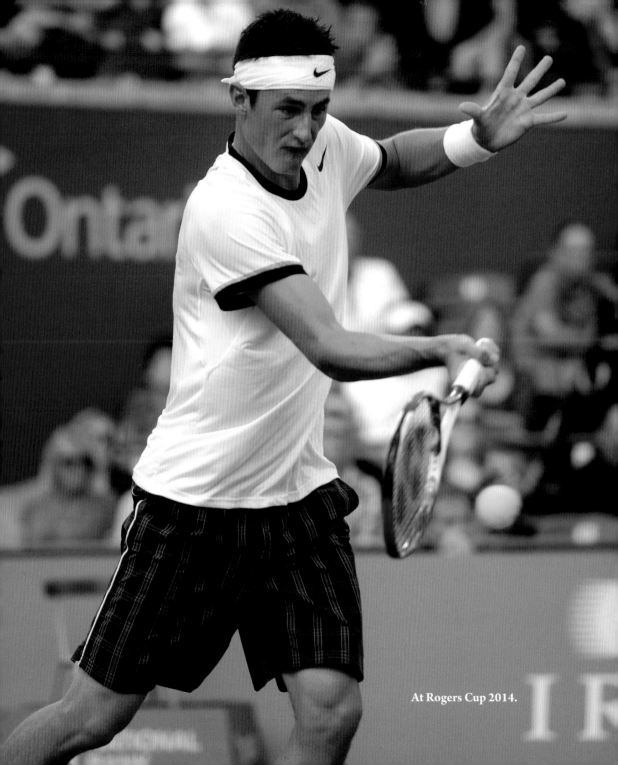

At Rogers Cup 2014.

wrote: "I watched Bernard Tomic come back from two sets down to beat Fernando Verdasco, and marveled at his quirky, inventive game." Macdonald said that Tomic reminded him, in many ways, of Andy Murray. Continued Macdonald: "But Tomic differs from Murray, and in fact surpasses him, in his imperturbable match temperament. He won against Verdasco by keeping his wits together from the third set on. By staying level emotionally, Tomic conserved energy and allowed Verdasco to self-destruct." Kevin Mitchell in the *Guardian* described Tomic in the 2012 Australian Open as " a player so comfortable with his game that he plays virtually without fear of failure. Shots others would love to take from the practice court to the big stage but dare not are second nature to him. He feathers, slices, feints and dinks."

By 2017, it was a different Bernard Tomic. He lost Wimbledon's first round, in straight sets, to Mischa Zverev. Later he said he was bored on court and hadn't really tried. He boasted to reporters that he had so much money he didn't care if he won or lost. Martina Navratilova (and others) said Tomic should get out of the sport if that's how he feels. "It's disrespectful to the sport and disrespectful to the history of the sport," said Navratilova. "If you can't get motivated at Wimbledon it's time to find another job." In an interview with the *Melbourne Herald Sun* after Wimbledon, he said, "You probably don't like me but, at only 24, you guys can only dream about having what I have at 24. End of the day, don't like me or whatever. Just go back dreaming about your dream car or house while I go buy them." He subsequently told another interviewer, "I don't regret what I said. That's why I said it, to piss a few people off."

He approached the 2017 US Open angry, demoralized, and in disarray. He told one journalist, "I feel holding a trophy or, you know, doing well, it doesn't satisfy me anymore, it's not there. So I couldn't care less if I make a fourth-round US Open or I lose first round." It's a good thing he didn't care, because he lost the first round, to Gilles Müller. That meant a new slump in the ratings. It was reported that a few days later he spent $50,000 in one night at an exclusive Melbourne nightclub. He was quoted as saying, "It [$50,000] might seem ridiculous to other people, but then again it is peanuts to me." He lost in the opening round of the October 2017 Vienna Open to qualifier Pierre-Hugues Herbert, after serving underarm at a key moment,

A dispirited Tomic at Halle,
just before Wimbledon 2017.

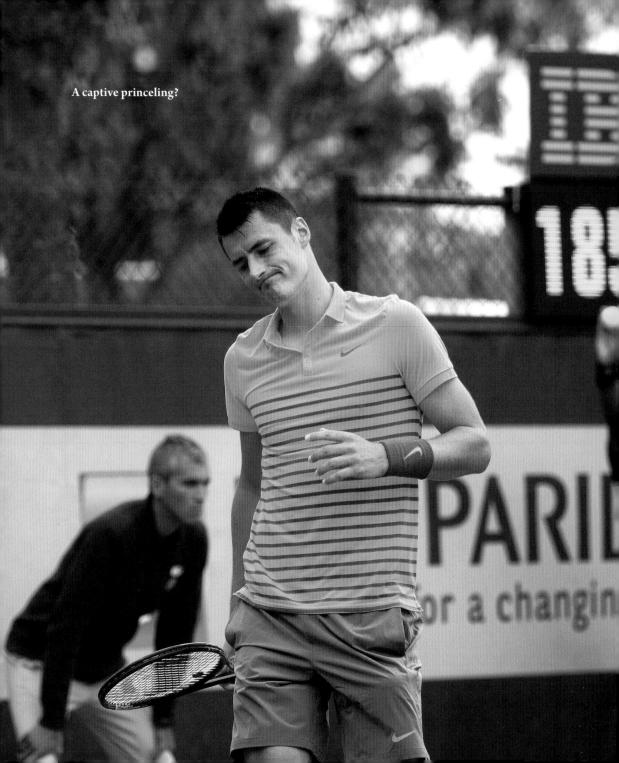

A captive princeling?

rounding out a terrible year. The Vienna Open was his 13th first-round loss in 2017 from nineteen tournaments.

Bernard Tomic was born in Stuttgart, Germany, in 1992, of a Croatian father and a Bosnian mother. They moved to Australia when he was three. His father drove a taxi. He quit school when he was sixteen. In a July 2017 interview with Australian television's Channel 7, Tomic said, "We came to Australia with basically nothing, it was tough. People don't see. We had a car—$200, $300. Now, maybe going buying cars half a million dollars to a million dollars, it's my choice. Living in these lavish houses, property around the world, it's my choice. It's something I've worked for and I've earned. Being 24 and achieving, in my opinion, a lot in the sport, it's affected me a little bit mentally and emotionally. So now it's just about finding my balance, and pushing on the next 10 years, and being successful even more." Bernard's younger sister, Sara, is also a tennis player, but not of her brother's quality.

In July 2017, after Tomic's disastrous appearance at Wimbledon and his equally disastrous comments afterward, Jacob Steinberg of the *Guardian* argued that the right thing to do upon hearing about the bad behavior of players like Tomic is to show a bit of empathy: "We can make an attempt to listen and understand when they speak. We can try to locate our empathy when these young people reveal their vulnerability in public and try not to push them away, to make them feel as if the world is against them by chastising and lecturing."

Or as Barney Ronay, also writing in the *Guardian* in July 2017, commented, "All that seems certain is that we should be kind, that we should save our repulsion for the system that gave us a generation of captive princelings."

KIDS

David Goffin

"When I was young, [Federer] was a Superman for me."—David Goffin

In 2017, David Goffin became the No. 1 male tennis player in Belgium and the first Belgian male tennis player to reach the ATP top 10. In 2017 he beat Djokovic (Monte Carlo), Monfils (US Open), Kyrgios (Davis Cup), and—spectacularly—Nadal in the ATP Finals (the *Guardian* commented, "Goffin was by turn heroic and profligate, as was the Spaniard—but it was the Belgian who held it together for the best result of his career.") The year before he beat Andy Murray (Abu Dhabi). In June 2016, the *New York Times* described Goffin as unflappable, a gentleman, and a player "with a rock-solid all-court game and a superb mental approach . . . with a game founded on foot-work, quick decision making and an uncanny ability to play every point with laserlike focus." There doesn't seem to be anything odd about him. He's not temperamental. He doesn't party publicly. He's not a racket-smasher.

Tennis fans started paying attention to Goffin in 2012 when he unexpectedly reached the round of sixteen at Roland Garros. His opponent was his childhood hero, Roger Federer. Greg Bishop wrote in the *New York Times* about the contrast between Goffin and Federer: "Roger Federer advanced to his 32nd straight Grand Slam quarterfinal at the expense of an opponent who looked more like Harry Potter, or perhaps Federer's own son . . . one man tall and tan, famous and regal, and the other, well, pretty much the opposite." But the match wasn't completely one-sided. It was closer than expected, as Goffin won the first set. He had arrived.

Goffin was born in 1990 in Rocourt, Liège, Belgium. When he was a child, Federer was his idol. He had Federer posters on his bedroom walls. At his first 2012 Wimbledon press conference, he was asked, "Did your life change since you played Roger Federer?" Goffin replied, "A little bit with the journalists and the media. More attention in my little city." The press persisted. "Does Federer seem a little less superhuman to you now that you've played him?" His reply: "Of course when I was young he was a Superman for me, but now I was against him and I was feeling good. I played

Unflappable and unassuming.

Just beaten by his hero Federer, Roland Garros 2012.

a great first set. But like I said before, it's behind me, and maybe I will play another match against him in next weeks."

At Goffin's second 2012 Wimbledon press conference, he was asked: "Obviously the top 4 in men's tennis is cemented. Those guys are very established. Then there's obviously other players like Del Potro and Ferrer, but then people are looking at a new generation and your name has been tipped as one of the new generation, one of the new kids on the block. Do you see yourself in that role? Do you think you can actually go on? Where do you set your sights?" He replied: "This week I'm 66. . . . I'm working to be near the top, but I'm still working and I have a lot of—I have something to work in my game, a lot of things to do to improve my game. I try to do my best to go on the top, but it's not an easy way. But I'm with a lot of confidence, and we will see."

As of the end of 2017, Goffin, at No. 7, shares a Top 10 ranking with his boyhood hero, at No. 2. At the ATP finals in November 2017, to the amazement of many, Goffin beat Federer in the semifinal. This came after he defeated Nadal in his first match, becoming only the sixth player ever to defeat Federer and Nadal in the same event. Goffin went on to lose in the ATP final to Grigor Dimitrov but, as the *Guardian* commented, "Goffin did not leave a loser."

Goffin was a serious contender at Roland Garros 2015.

Dominic Thiem

"I think that's pretty far away."—Dominic Thiem,
when asked if he's "the next big thing."

The Hunger Gap. That's what Christopher Clarey of the *New York Times* called it. He was trying to explain Dominic Thiem's 2017 Roland Garros quarterfinal straight-sets defeat of Novak Djokovic. In the last set, Thiem beat the world No. 4 by a startling 6–0. Thiem was hungry, and Djokovic, not so much, said Clarey. Though Thiem lost to Nadal in the semifinal, his hunger had been exposed for all to see. One day, they say, perhaps soon, he will win the French Open.

The twenty-three-year-old Austrian is not just hungry. He is talented, disciplined, and strong. He's sometimes called the hardest-working man in tennis. He's known to train very hard, up to 12 hours a day. Tennis watchers comment on his mental strength. He has been called "humble" and "straightforward." To those who say he's the "next big thing," Thiem replies, "It's nice to hear that, but still I think that's pretty far away." Some find him taciturn and boring. A September 2017 profile in *GQ* magazine called him "glacially calm."

Thiem's upward trajectory is remarkable. His first big win was in the second round of the 2014 BNP Paribas Open at Indian Wells, when he beat Gilles Simon, the former world No. 6. Thiem won his first career ATP World Tour title the following year in Nice, defeating Nick Kyrgios, Ernests Gulbis, and John Isner along the way. At the 2016 French Open, Thiem reached the semifinals of a major for the first time. He lost to Novak Djokovic, who beat Andy Murray to win the final. When, a year later, he defeated Djokovic at the 2017 Roland Garros quarterfinal, Thiem was fresh from beating Rafael Nadal on clay in Buenos Aires a few months earlier and Roger Federer on grass in Stuttgart the week before. By then, he was ranked No. 7 in the world and was one of a small group of young players (including Nick Kyrgios and Sascha Zverev) threatening the established tennis order, particularly on clay. It's beginning to become clear why Thiem's nickname is "The Dominator."

Thiem and Djokovic after
Thiem's victory at Roland
Garros 2017.

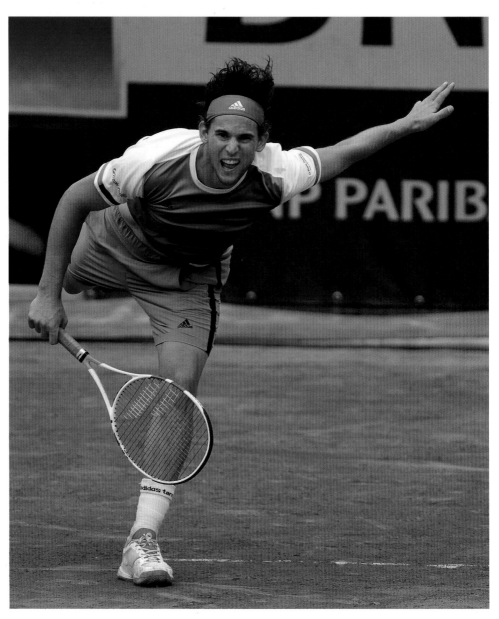

The Dominator.

There's not a lot to say about Thiem, a focused and disciplined young man. There's not much that's odd or colorful and there's nothing flamboyant. Nevertheless, it was reported that when the Duchess of Cambridge, future Queen of England, attended Wimbledon 2017, "she ended up in fits of giggles as she was introduced to hunky Austrian player Dominic Thiem, 23. And it may well have crossed the mind of the world number eight that the Duchess bears more than a striking resemblance to his girlfriend Romana Exenberger, a former beauty queen with the same flowing brunette locks and porcelain skin." Exenberger is no more. His new girlfriend as of late 2017 is Kristina Mladenovic, a French tennis player.

Thiem has been immersed in tennis from a preternaturally young age. Both his father, Wolfgang, and his mother, Karin, are professional tennis coaches (Wolfgang coaches Sebastian Ofner, who beat Jack Sock in the second round of Wimbledon 2017, to every commentator's great surprise). He has had the same coach, Günter Bresnik, for over a decade. Bresnik, who coached Boris Becker and Ernests Gulbis, has known him since he was four years old, when Dominic's father came to work at Bresnik's Vienna tennis academy. Bresnik had studied to be a doctor and did not start playing tennis until he was sixteen. He has said, "My parents were both doctors, and my sisters are both professors, and the idiot Günter is the tennis teacher." In a prescient move, reminiscent of Toni Nadal persuading his nephew Rafael to become a lefty, Bresnik made Thiem abandon the usual two-handed backhand for a one-handed backhand that has become one of Thiem's most powerful weapons.

Bresnik coached Thiem and Gulbis at the same time, and the two players became close friends and training partners. At the 2014 US Open, Thiem beat Gulbis in the second round in five sets after losing the first two. Of Thiem, Bresnik said, "To fight the match out like this, there is some special quality the kid has."

At the end of 2017, Dominic Thiem was ranked No. 5. Some say that the Big Four have held back younger players, those seven or eight or nine years younger than them, who in a different era would have easily occupied the top rankings. But they cannot hold back players more than ten years younger, players like Dominic Thiem, for long.

Günter Bresnik.

The right way to play?

Sascha Zverev

"I'm surprised what people expect from me."—Sascha Zverev

There are two Zverevs, Sascha and Mischa. They're brothers. Both are top players, but Sascha (real name Alexander), the younger by ten years, is much better than Mischa, at least judging by the rankings. They say Sascha is a sure bet to reach world No. 1. Just about everybody, including Roger Federer, thinks he is the future of tennis. He's been called "the anointed one." He's been described as the "apex predator."

Sascha Zverev was born in Hamburg, Germany in 1997. The family moved from Sochi, Russia, to Germany in 1991, the year the Soviet Union fell apart, before Sascha was born and when Mischa was a toddler. Sascha has already won over $6 million in prize money and has earned even more from endorsements. He wears a Richard Mille watch worth more than $700,000 (Rafael Nadal has one too). At the end of 2017 he was world No. 4, while Mischa was No. 33.

Sascha is six-foot-six. Some say that's a huge advantage, but others, citing health risks associated with height, are not so sure. He's a big and aggressive hitter from the baseline with a superb two-handed backhand and excellent footwork for such a tall player. He has what is called "elasticity." In May 2017, he defeated Novak Djokovic on clay at the Italian Open. In August, he beat Roger Federer in straight sets to win the Rogers Cup in Montreal. They say his game is technically nearly perfect.

Sascha is good-looking, handsome even, in a surfer-dude kind of way. *Vogue* magazine had trouble restraining its enthusiasm: "There is something almost princely about him—his six-foot-six height, the mop of burnished blond waves, the leonine eyes that seem to change color with the light, the long and loose limbs." Giri Nathan in the *Washington Post* writes, "With watermelon-pink shorts, and a golden mop above a slightly glassy expression, he looks a bit like a seeker who went out in search of killer waves and washed up on hard court." Sascha loves his dog, a poodle called Lovik, and takes him everywhere.

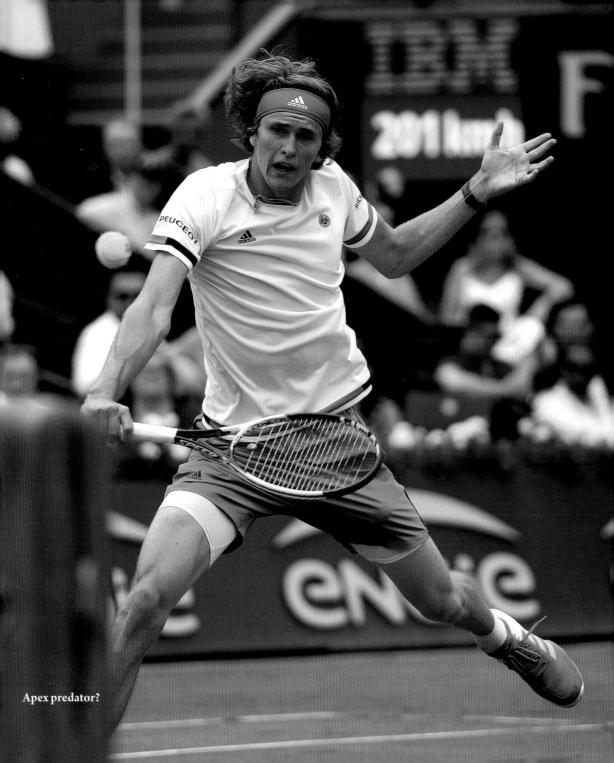

Apex predator?

At Halle 2017, wearing his $700,000 watch.

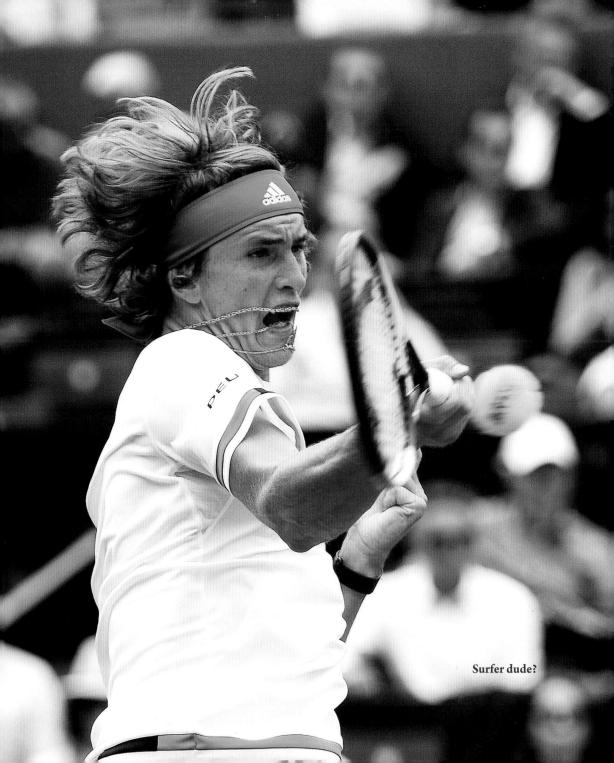

Surfer dude?

With his mother, Irina.

The Zverevs are a tennis family. Sascha has been coached by his father, Alexander Zverev, Sr., with help from his mother, Irina Zvereva. (In 2017, former world No. 1 Juan Carlos Ferrero was added to the coaching team.) Alexander Sr. was a member of the Soviet Davis Cup team in the 1980s. His mother was once ranked No. 4 in the Soviet Union.

Sascha attributes some of his precocity to his family's immersion in tennis and particularly to hanging around his older brother. Sascha followed Mischa around starting when he was about eight years old and Mischa was competing as a junior. The world of competitive tennis became familiar to Sascha. He knew the locker room. He knew the tennis courts and their atmosphere. It was natural for him to pick up a tennis racket. He was catapulted into the game.

"He was living it with his brother," Zverev's agent, Patricio Apey, has said. At his US Open pregame press conference on August 26, 2017, Sascha was asked about Andy Murray, another player with a brother on the pro tour. Sascha said: "I have known Andy or Andy knew me since I'm four, five years old, and it's always great, you know, to know that I have known them and know who I was before I even started playing on tour. I was always pretty welcomed by those guys, by Novak, by Andy, by other guys similar age, plus my brother played juniors with them."

But there's a mystery about Sascha Zverev. He's hailed as the future of tennis, but thus far can't seem to get anywhere in the Grand Slams, the most important measure of tennis success. His Grand Slam drought is exemplified by what happened at the 2017 US Open. This was the one that was going to be different. Zverev himself said as much, on several occasions, in several different ways. At a pregame press conference, he said, "I feel different about this Grand Slam than I have felt before about the Grand Slams. So, you know, it's obviously Roger and Rafa are the biggest favorites still. I think how the year has been going, they are still on top of everyone. But, you know, I'm just going to go match by match and hopefully I can get to those guys." But he didn't get to those guys, not even close. He lost in the second round to Croatia's Borna Ćorić, ranked outside the top 50. At his postgame press conference, Zverev said, "It's upsetting. Today was upsetting. The way I played was upsetting. The tournament

Losing to Fernando Verdasco,
Roland Garros 2017 first round.

so far is upsetting for me. I know that I could have done some big things here. I know that I could have done something that I haven't done before. But I won't. It's just as simple as that."

At the ATP finals in November, Zverev lost to Jack Sock. He told a reporter: "The end of the year was absolute crap for me. If I would have played the whole year like I did, by the end of the year I don't think I would have finished top 50. Yeah, that's a bit unfortunate for me. But that's okay. I'm going to go on holidays now. I'm definitely going to enjoy that. Then I'm going to work hard in the off-season."

Denis Shapovalov

"I am not rushing. . . . This is a long road."—Denis Shapovalov

At the end of 2016, Canadian Denis Shapovalov had clear goals for his rookie year as a tennis professional on the ATP Tour. "Well, qualifying for a Grand Slam would be great, to win a Challenger, getting to Top 200, perhaps 150." he said in a November 2016 interview at the Ontario Racquet Club. He paused, and then continued. "I am not rushing. I will be only 18 and this is a long road. There is a lot of maturing to do. On and off the court."

After a win at Junior Wimbledon in 2016, Shapovalov decided it was time to play better players, to leave the safe confines of junior tennis behind, and to focus on the transition to the professional level. "It really wasn't tough to decide," he said in the Ontario Racquet Club interview. "I was ready for the pros and played Futures [the lowest level of pro tournaments] before. It was totally my decision. My team had a lot of impact guiding me through the process, but ultimately I've decided to do this." He seemed confident in his decision. "I knew I had a level to do it. My game allows me to be good, and I am not afraid of going for the shots."

The transition from a junior tennis player to a professional is difficult. Only a handful of top-ranked juniors can do it successfully. The ups and downs of life on the road, the pressure of playing in a big stadium before a big audience, the challenge of playing more experienced opponents, the travel bills, and the microscopic attention of press and coaches all take their toll.

Shapovalov started to prepare for 2017 by spending time in Vienna working with one of the best coaches in the game, Günter Bresnik, and training with rising star Dominic Thiem. The Davis Cup in January, in Ottawa, was an emotional test. Martin Laurendeau, Team Canada's captain, decided to put Shapovalov in as one of the singles players against Great Britain (Shapovalov moved to Canada from Israel before his first birthday). Shapovalov faced two British players ranked in the Top 60, Kyle Edmunds and Daniel Evans. After badly losing his first singles match against Evans, Shapovalov played the last match when the score was tied at 2-all. If he won the match, Team Canada would advance to the quarterfinals of the Davis Cup World Group. The pressure was intense. In a moment of

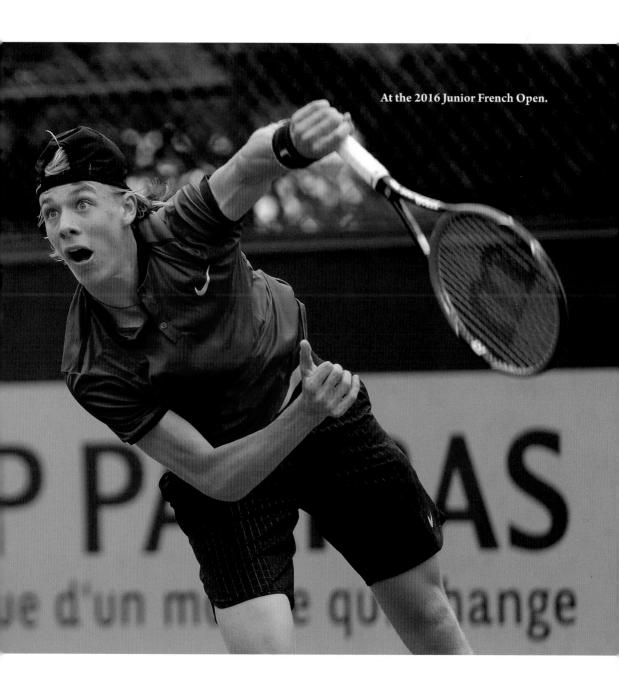

At the 2016 Junior French Open.

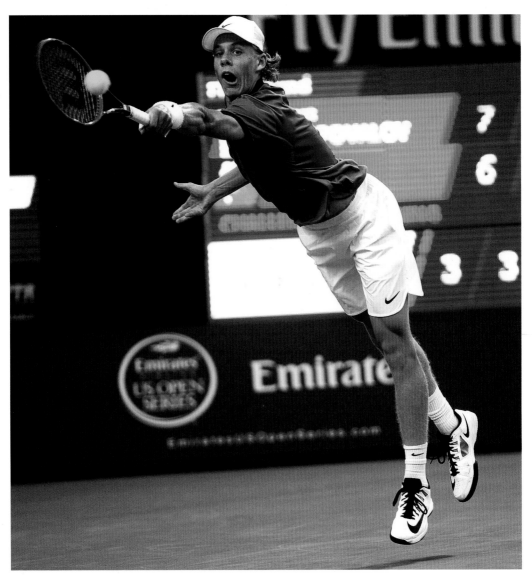

On the big stage—Rogers Cup 2016.

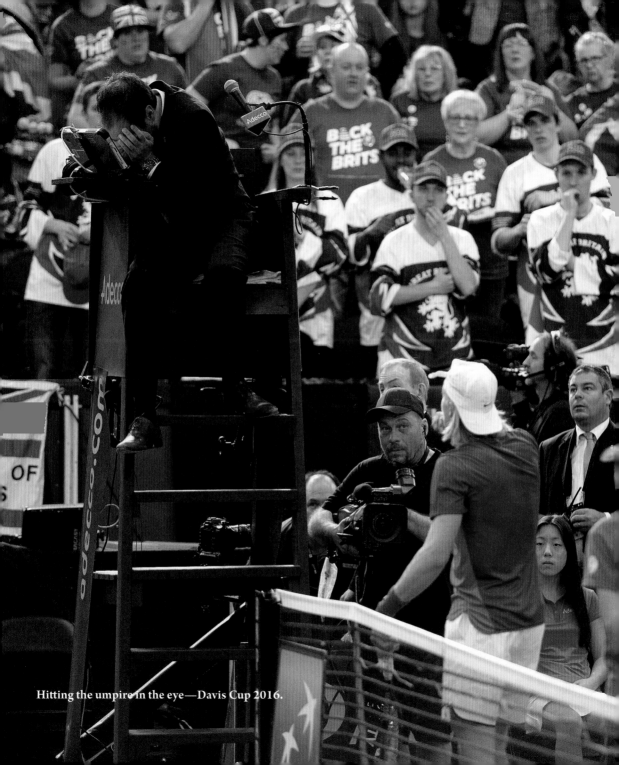
Hitting the umpire in the eye—Davis Cup 2016.

frustration during the match, Shapovalov fired a tennis ball into the crowd, hitting chair umpire Arnaud Gabas in the eye. Shapovalov lost the match by a default (he was also fined $7,000) and as a result gave Great Britain a 3–2 win and a trip to the quarterfinals.

Shapovalov handled the situation with maturity. His manager, Martin Laurendeau, told him that he "had to face the music." Shapovalov asked to speak with Gabas and apologized for what had happened. He also faced the media at the Davis Cup press conference, issued a statement, and let the team captain, Laurendeau, answer questions. Then he drove home with his family from Ottawa to Thornhill, a four-hour trip.

Asked about Shapovalov's future, and his ability to control his emotions, Laurendeau told the *Globe and Mail* in February 2017: "Emotion is good in tennis if you can channel it the right way and Denis is a very creative guy on the court, so we don't want him to lobotomize himself and remove all of his emotions along with the terrific passion in his game. What he did wasn't acceptable and we want him to manage the emotions. He's a humble kid and a fantastic prospect. We think his tennis can do the talking."

Mats Wilander, a former world No.1 and seven-time Grand Slam champion, said of Shapovalov, "he is a serious talent." He went on: "To be 100 percent honest you cannot compare Shapovalov to any other youngster. He is a completely different level. It is like watching a combination of Nadal and Federer at 18 years old. He has the fire of Nadal and the speed around the court of Nadal, and he has the grace of Federer—it's unbelievable. He really captivates the crowd."

It started in Thornhill (the same Toronto suburb where Milos Raonic began), and under the tutelage of his mother, Tessa Shapovalova, who was a professional tennis player herself (ranked around 300 on the WTA tour, then representing the former Soviet Union). The family moved to Israel where Denis was born, and shortly thereafter to Canada, where they settled.

Denis started playing tennis at age five. "I couldn't move him off the court—he played with big kids, little kids, anyone," says his mother. She is often credited for Denis developing a style that already makes him easily recognizable on the Tour—a powerful serve, a one-handed backhand, and aggressive shots that suit his athleticism and assertiveness. He trained with Tennis Canada in one of the national junior programs from the age nine to eleven, but Ms. Shapovalova felt that a more individual approach would benefit Denis the most. At thirteen, he started working with Adriano Fuorivia, who became his personal coach.

With his mother, Tessa.

In 2016, Shapovalov became Canada's Under 18 outdoor champion and then made it to the semifinals of the junior Roland Garros (losing to the eventual champion, Frenchman Geoffrey Blancaneaux). A few weeks later he became the third Canadian to win Junior Wimbledon (Filip Peliwo and Eugenie Bouchard, who won in 2012, are the other two). In February and March 2017, Shapovalov was playing a mixture of lower level events with some main Tour tournaments (where he was awarded wild cards). In May he was back at Roland Garros, this time not as a junior; he lost in the first round in the qualifying tournament to the number-one-seeded Romanian player, Marius Copil. At 2017 Wimbledon he was awarded a wild-card entry into the main draw, as the 2016 junior champion, but lost in the first round to Jerzy Janowicz of Poland.

And then, in July, the Rogers Cup in Montreal happened. At this point Denis Shapovalov was largely unknown by tennis fans. He was awarded a wild card, but a tough draw lay ahead. In the second round he faced Juan Martín del Potro, and then Rafael Nadal. His team and entourage were impressive: both Wayne Gretzky and Olympic Gold medalist Penny Oleksiak showed up to support him. While he brushed with sports royalty during the day, at night he bunked in the basement of a tennis friend, Félix Auger-Aliassime. Shapovalov beat del Potro. The morning before the Nadal match he stared up at a poster of Rafael Nadal. He asked Félix, his host, for permission to tear it down. He electrified the crowd with great shotmaking, raw talent, and nerve. He beat Nadal and made it to the semifinals. It made him the youngest ATP World Tour Masters 1000 semifinalist since the series started in 1990.

After his run in Montreal, Shapovalov won three qualifying matches to get into the US Open main draw and defeated Jo-Wilfried Tsonga en route to his maiden Grand Slam fourth-round appearance, before losing to Carreno Busta. He was the youngest player to reach that stage at a major since Marat Safin at the 1998 French Open. The dream summer continued into the autumn when Shapovalov took part in the first-ever Laver Cup in Prague, was awarded Most Improved Player on the ATP Tour in 2017, was named a 2017 Star of Tomorrow, and played in the first edition of NexGen ATP Finals in Milan.

As of the end of 2017 Shapovalov was ranked No. 51. What are his plans for the future? "A tour title, adding weapons to my game, and to avoid tour struggle." He doesn't want, after huge success, to disappear down the rankings rabbit hole.

One of the youngest players on the Tour.

TRIED AND TRUE

Tommy Haas

"You can't lose it. Fight!"—Tommy Haas

Tommy Haas never gives up. You've got to admire him for that. His extraordinary tenacity is a big part of the story. In a March 2017 *New Yorker* story about the future of tennis, Louisa Thomas began: "Tommy Haas, the thirty-eight-year-old German tennis player, was once one of the top players on the A.T.P. tour; he is now one of the oldest."

Haas, born in Germany, is a dual German and American citizen who plays tennis under the German flag, although he often identifies as an American. He lives in Los Angeles and Sarasota, Florida. He is married to the actress Sara Foster, daughter of David Foster, the Canadian composer and record producer (Sara is a friend of Mirka Federer; Tommy and Roger are also friends). He has two young daughters who he says are his inspiration. His idol has always been another German tennis player, Boris Becker. Haas is one of a handful of players who have kept the old-fashioned, elegant, one-handed backhand.

Tommy Haas's breakthrough was more than twenty years ago, in 1997, a year after he turned professional, at the age of nineteen. Haas, who finished the year ranked No. 45, had a spectacular early career. In 1998 he beat Andre Agassi at Wimbledon in the second round. The following year, he advanced to the Australian Open semifinal, defeating Lleyton Hewitt in the second round. In 2000 he beat Federer in the semifinals of the Sydney Olympics and won a silver medal. Two years later, he reached his highest ranking ever, No. 2 in the world, despite family tragedy. In June 2002 his parents were in a serious motorcycle accident, riding a Harley-Davidson that he had given them; his father suffered permanent brain damage.

Since 2002, it has been hard going for Haas, a long downward slide propelled by injuries (shoulder, rotator cuff, elbow, ankle, hip, and foot, with nine surgeries in all), punctuated by announcements of imminent retirement but also by unexpected and gratifying victories. He missed the entire 2003 season. In 2004 he was named ATP Comeback Player of the Year, but he didn't get back into the Top 10 until 2007. After

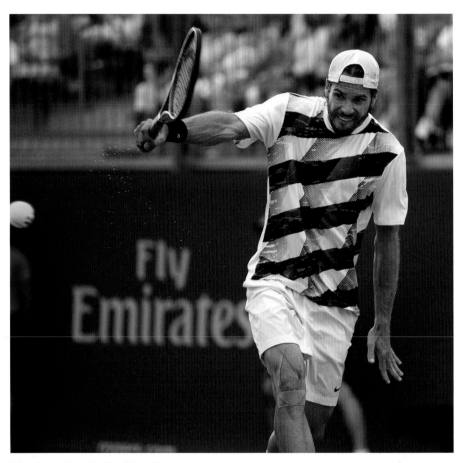

Haas's one-handed backhand was considered one of the most elegant strokes on the ATP Tour.

In 2012 Haas didn't even have a steady clothing contract, using various outfits and changing them during matches.

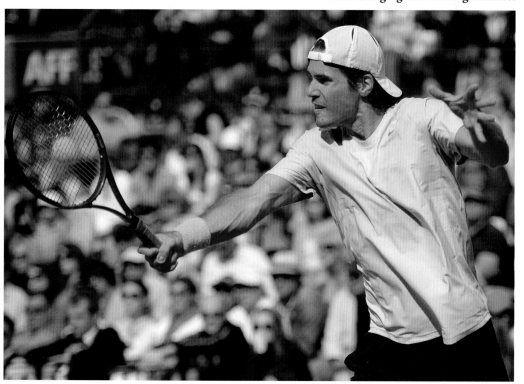

a successful 2009, he missed almost eighteen months in 2010 and 2011. He started 2012 ranked 205 and ended it ranked 25, the oldest player inside the Top 50; once more, he was named Comeback Player of the Year (besides Haas, only del Potro has been named Comeback Player twice).

In 2013, he finished at No. 12. This included a victory over Novak Djokovic in March at Key Biscayne, where he became the oldest man in thirty years to defeat a No.1 player. In 2014, he retired from play four times because of a shoulder injury, ending the year as No. 77. Then Tommy Haas pretty much disappeared, until his surprising reemergence in 2017.

Haas's career has been one of setbacks. He doesn't always deal with disappointment with equanimity. Christopher Clarey in the *New York Times* has written that he has "a deeply ingrained negative streak, a tendency to gripe and snipe at his coaches and support team under pressure, and a propensity for finding fault with elements beyond his control."

Haas has said that 2017 was his last year as a professional player. It was a farewell tour. It was his final comeback. He says he wanted to finish "on my own terms." He wanted his older daughter, Valentina, to be able to watch him play. "I would love to see [her] sit in my box the next few months and watch her daddy play and realize what I'm doing and really remember that for the rest of her life." He's thirty-nine, the same age as Jimmy Connors when he stopped playing on the tour. Now Haas will concentrate on his new job, tournament director of Indian Wells.

He started 2017 ranked No. 1,028. At the Australian Open, in January, suffering from breathing difficulties, he retired from his first-round match against No. 48 Benoît Paire. At Delray Beach, in February, he lost his opening-round singles match to No. 87 Nikoloz Basilashvili. At the Miami Open in March, he again lost in the first round, to No. 54 Jiří Veselý. (His game against Veselý was temporarily stopped when a wild iguana invaded the tennis court.) Then in April, at Monte Carlo, to general surprise and satisfaction, things suddenly changed: Haas beat Paire—the 2016 Comeback Player of the Year—in straight sets in just over an hour. The website *ATP World Tour* commented, "Maybe Tommy Haas should reconsider this whole retirement thing." Paire's offensive comment on his opponent? *Le mec est nul.* ("This guy

With his daughter Valentina at Halle 2017.

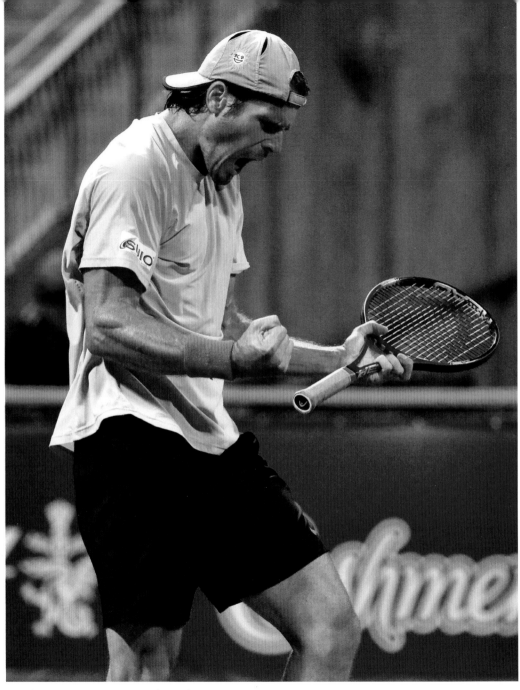

Haas's on-court intensity was legendary.

is a nobody.") And then, something amazing: Haas beat Federer in the second round at Stuttgart in June.

Fresh from beating Federer, Haas had a wild card for 2017 Wimbledon. Would something wonderful happen there? It didn't. He was beaten in the first round by a little-known Belgian, Ruben Bemelmans. The crowd gave Haas a standing ovation. Said Haas, "I'm happy to have somehow made it out on the court and I just have to continue to fight that battle until I know it's finally done."

Nothing captures Haas's spirit better than his famous "chat with himself" at the 2007 Australian Open, where he was playing Nikolay Davydenko in the quarterfinal. Down a service break in the fourth set, Haas was caught on the microphone talking to himself: "You can't win that way, Haasi. It's not possible. It doesn't work that way. It doesn't work. Just too weak. Too many errors. Too many errors. It is always the same. I don't want this anymore. I don't feel like it. Why am I doing all this shit? For what? For whom? Except for myself. Why? For which reason? I can't do it. I don't get it. I'm paying people for nothing. For absolutely nothing. That I can get excited over it. You're a retard. Once again, you didn't go to the net. Nicely done. But you're gonna win. You'll win that match, come on! You can't lose it. Fight!"

Haas went back on the court and won the next point, as well as the fifth set and the match.

Daniel Nestor

"No one wants to play with me anymore."—Daniel Nestor

Italian journeyman Cristiano Caratti (who reached a career high rank of world No. 26 in July 1991) bumped into John McEnroe on his way to a practice session before a first-round match at the 1992 Canadian Rogers Cup.

McEnroe said, "Hey Cristiano, who are you playing?" Caratti replied, "Some guy I've never heard of, Nestor from Canada." "Be careful," said McEnroe. "He beat Edberg in the Davis Cup this year."(Stefan Edberg was then ranked No. 1 on the ATP Tour.)

McEnroe was right to caution Caratti. Daniel Nestor (then ranked 176 in singles) won that 1992 match against him, 6–4, 6–4. McEnroe knew that Nestor was a rising star with a powerful serve who had shown, with his win over Edberg, that he could handle a big stage. In the years to come, Nestor turned out to be a solid tour player (he reached No. 58 in 1999), and in his singles career he beat five No. 1 players—Stefan Edberg, Thomas Muster, Patrick Rafter, Gustavo Kuerten, and Marcelo Ríos.

What no one predicted was that Nestor would become one of the best doubles players in history. He was the first doubles player to win more than one thousand matches on the tour, including a Grand Slam and an Olympic Gold Medal (Sydney 2002, with Canadian Sébastien Lareau). He was also the first doubles player to win all Masters level tournaments, and he is the first player in tennis history to win all Grand Slams, all master tournaments, and an Olympic Gold medal. Only Bob and Mike Bryan matched this later on, and no singles player accomplished that. At the end of 2017, at the age of forty-six, he ranked No. 56 and remained tied with Mike Bryan for a record 1,056 doubles match wins in the professional era.

Wimbledon champion Andy Murray was asked a couple of years ago how he felt about Nestor, the oldest active player on the tour, being part of locker room camaraderie, and he said, "Let's just put things into perspective. I am 27 years old and he is playing his 26th Rogers Cup!" Bob Bryan (Mike Bryan's twin brother) described Nestor to the Toronto *Globe and Mail* in 2012 in simple words: "He is a legend.

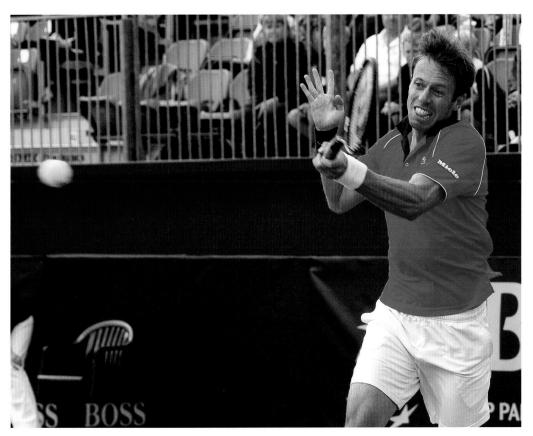

Davis Cup 2010 in Toronto.

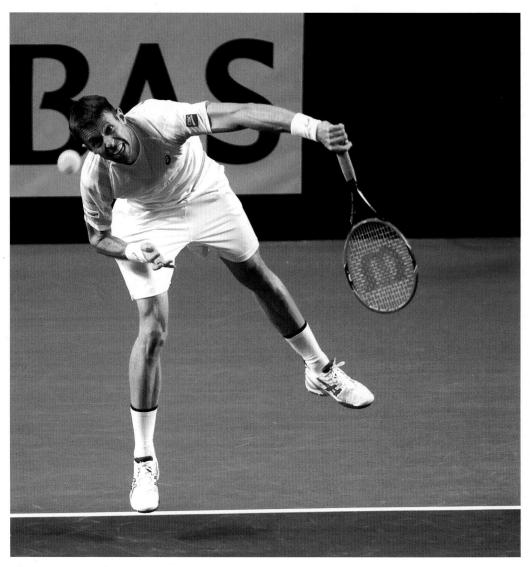

The Nestor serve, Davis Cup 2015.

With Pakistani Aisam-ul-Haq
Qureshi at Roland Garros 2015.

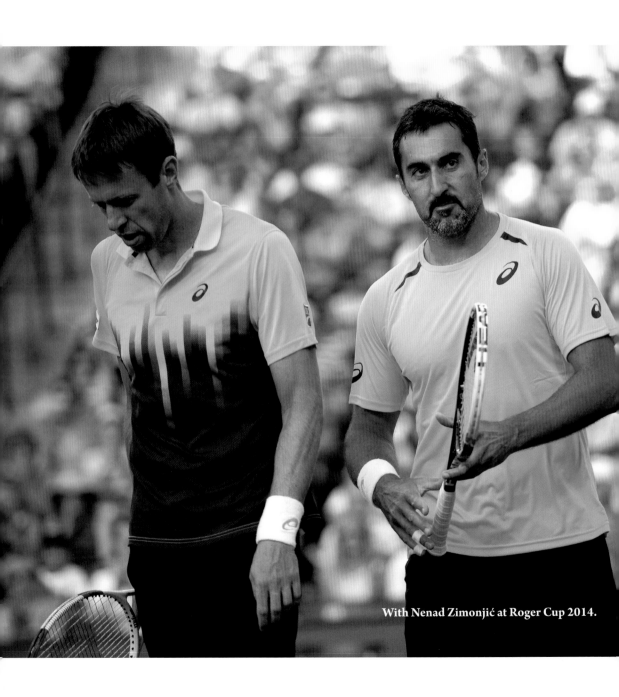

With Nenad Zimonjić at Roger Cup 2014.

With his wife Natasha, being
inducted into the Canadian
Walk of Fame.

An incredible athlete, flexible, limber. He is still playing like he is 20. That serve that he has is timeless. That serve will probably carry him until he is 50."

"This game [doubles] is a lot like marriage" Nestor told *Walrus* magazine in 2010. "It takes trust, communication, and balance, but first—you have to find someone you are compatible with." But when you are over forty, competing with kids half your age, who are not only stronger but take pride in beating a legend, and do not like to be teased for losing a match to the "old guy," it can be hard to find a partner. "No one wants to play with me anymore," he said in 2016 when he was asked why he didn't have a regular partner. He added: "The worst doubles team in the world right now— Nestor and anybody!" (Nestor often jokes about himself, displaying his down-to-earth personality and sarcastic sense of humor.)

But it wasn't always like that. Once Nestor had steady partners. There was fellow Canadian Sebastien Lareau. After the Sydney Olympics in 2002, when Lareau retired, Nestor found the young Bahamian, Mark Knowles. "We were successful right from the start, but probably not as successful as we should have been," says Nestor. After several years, Nestor started playing with Nenad Zimonjić from Serbia. "Yeah, we started winning right from the start." They won three Grand Slam titles in three years.

Now, as his career comes to an end, Nestor has trouble finding a partner and winning a round or two in any tournament. But he keeps playing. "I am still playing well enough to be out there, and this is what I am good at." Many consider him the most accomplished world athlete that Canada has ever produced, but he can walk anywhere and not worry about crowds surrounding him. As Andrew Clark wrote in *Walrus*, "Most Canadians have heard the name Daniel Nestor at one time or another. They just have trouble placing him. Musician? Architect? Iron Chef?" He is not complaining. "I've had a good career," he says modestly of a career that has earned him almost $13 million in prize money. "I got an Order of Canada, a star on the Canadian Walk of Fame. What more I can ask for?"

Ten years after his launchpad win over Stephan Edberg, he faced another World No. 1 singles player, a brilliant player from Chile, Marcelo Ríos. Nestor was now a doubles specialist and rarely played singles. But as the anchor of the 2011 Canadian Davis

Cup team, he was thrown out to face Ríos in a pivotal singles match. His countrymen cheered Nestor on to victory. As Eric Duhatschek wrote in the *Globe and Mail*, Ríos was offered any possible excuse—the altitude, his level of fitness, the dark building, the very fast court—but all he could mumble, over and over again, was some dumbfounded variation of "but, I lost to a doubles player." It came as a shock to all, but also as a testament to Nestor's depth, grit, focus, and heart of a champion.

CONCLUSION

Men's professional tennis is rich in characters. There are the giants of the game, the names that everyone knows, the players whose careers, personal lives, and peculiarities have been endlessly examined by commentators and the press. For years the giants have been the famous, now fading, Big Four. There are the less well-known players, the contenders, those who have been crowding the Big Four, in some cases for many years, dancing on the periphery of greatness, hoping to take the place of the kings of the game. Most of the contenders, some young, some not so young, will fall short of their ambitions, but their careers and lives, their victories, and even more so their defeats—some of them described in this book—tell us much about the game. A handful will realize their ambitions and step into the shoes of the Big Four. All of them, winners and losers alike, play their part in the theatre of tennis, what the *Times Literary Supplement* in January 2018 called "a sport that provides us with an all-purpose set of metaphors, a kind of cultural shorthand."

Some of the contenders, not talented enough technically, or without the cool discipline the game requires, will drop away in the years to come, sooner rather than later. Will we hear much more about, say, Bernard Tomic or Fabio Fognini? What about Nick Kyrgios? (Perhaps he is here to stay.) Others will continue for a time to nip at the heels of the Big Four, regularly displaying maturity and brilliance on the court, but as they age their hopes must fade. Will Gaël Monfils ever win a Grand Slam? Will Stan Wawrinka win Wimbledon and achieve a career Grand Slam? Will Juan Martín del Potro be the comeback kid yet again? Marin Čilić suddenly is a major contender, but does he have what it takes to become world No. 1?

The young contenders show much promise, but they are not yet seriously battle-tested. Can they last the course? Some of them came roaring into 2018, but met quick

disappointment. Denis Shapovalov was knocked out of the 2018 Australian Open in the second round, along with David Goffin. Sascha Zverev only lasted to the third round. Dominic Thiem managed to make the fourth round. 2018 has not begun well for these promising players. Who will survive the punishing ATP Tour? Who will be forgotten? The road to greatness is a long road. Many drop by the wayside.

After the 2018 Australian Open, won by Federer, the *Guardian* newspaper speculated: "An intriguing scenario is unfolding in the wake of Roger Federer's sixth Australian Open triumph in which the ageless Swiss arrives at the 2020 Tokyo Olympics to join his long-time rivals, Rafael Nadal, Novak Djokovic, and Andy Murray, in a grand farewell to their illustrious careers."

If the *Guardian*'s prediction is right, there's two years to go. The old days are not over yet, but they will come to an end soon. And then new days will begin.